TAKING OUT THE GUESSWORK

USING RESEARCH TO BUILD ARTS AUDIENCES

BOB HARLOW

Copyright 2015 The Wallace Foundation

Editor: Jennifer Gill

Cover photo: Iain Crockart

Cover design: José Moreno

Interior design: Tom Starace

Published by Bob Harlow Research and Consulting, LLC, New York, NY

ISBN 978-0-9847287-8-7

Library of Congress Control Number: 2015906139

TABLE OF CONTENTS

PREFACE

Most arts managers would agree that building and strengthening audience relationships are top priorities. Few organizations, however, agree on the importance of conducting audience research to support those activities. Even organizations that say they value audience research find reasons not to do it. A lack of resources—money, time, and skills—is often cited, and it may not be clear that the benefits of conducting research justify the expense. As a result, it just does not get done.

This guidebook was developed to help organizations jump some of these hurdles. It was born out of strong evidence that audience research can strengthen audience-building initiatives by helping institutions understand how to build meaningful connections with different groups. Based on work with a diverse set of arts organizations undertaking multiyear audience-building initiatives, as well as on literature reporting broader research practices, it illustrates how research can support three tasks integral to successful audience building: (1) learning about potential audiences, (2) creating more effective promotional materials, and (3) tracking and assessing progress toward audience-building objectives.

The guidebook has two purposes. First, it shows how audience research can lead to better audience-building results. There are chapters about each of the three applications mentioned above, and each chapter provides examples of organizations that used findings from audience research to sharpen their approaches. Their efforts bear witness to the fact that carefully planned research—combined with a willingness to listen, even when the feedback is difficult to hear—can help organizations win new audiences.

The book also includes detailed guidelines for arts organizations' marketing directors and others who want to design and manage their own audience

research. It is by no means a survey of all audience research techniques. Instead, the guidebook deliberately focuses on the research methods that are the most widely used and accessible to organizations with little or no experience in doing audience research.

I am grateful to The Wallace Foundation for supporting this work, as well as to staff members Rachel Hare Bork, Lucas Held, Pam Mendels, Ed Pauly, Ann Stone, and Christine Yoon for their feedback and counsel as the guidebook was developed. The staffs of the organizations whose work is described in detailed examples—The Clay Studio, Fleisher Art Memorial, the Isabella Stewart Gardner Museum, Minnesota Opera, Pacific Northwest Ballet, and San Francisco Girls Chorus—were generous with their time and in sharing their experiences and results. It was their ingenuity that inspired this work. Their research partners, including Martin & Stowe, Inc., Slover Linett Audience Research, Inc., and Strategic Action, Inc., were also generous with their input and permission to reproduce research materials. Editor Jennifer Gill reshaped the text to ensure continuity and clarity and found the words, phrases, and metaphors that would simplify the mechanics, but not the ideas—no easy task for a research guidebook. Elizabeth Bolander of the Cleveland Museum of Art, Pamela Pantos of Opera North, Melanie Smith of San Francisco Girls Chorus, Kay Takeda of the Lower Manhattan Cultural Council, and Lani Willis of Minnesota Opera provided guidance on the overall concept. Their enthusiasm for audience research and the time they spent providing thoughtful feedback were much appreciated. Finally, feedback from members of the Cultural Alliance of Fairfield County on an early draft helped to refine and present the material herein.

INTRODUCTION

Audience building often means venturing into uncharted territory. You may have no idea what potential audience members think about your art form or organization, or even if they know you exist. You may also not know what they're looking for in terms of cultural activities or how your programming can fit into their time-pressed lives. Despite the unknowns, a surprisingly large number of audience-building initiatives move forward with little input from the very people organizations are looking to attract. That's like inviting guests to dinner without first finding out what they like to eat or what food allergies they may have, says Magda Martinez, director of programs at Fleisher Art Memorial. On a practical level, it can mean committing resources to initiatives that may prove unsuccessful.

This work doesn't have to require such a leap of faith. Strategically designed audience research can remove a lot of the guesswork that comes with creating and fine-tuning programs to attract new visitors. It can stimulate ideas about how to make an institution and its art more accessible to newcomers, identify obstacles that are getting in the way of engagement, and suggest strategies for overcoming them. As an initiative unfolds, research can illuminate what's working, what's not, and why. It can also sharpen marketing efforts, boosting the effectiveness of even a small budget. In short, strategically and judiciously used research can help organizations win audiences.

This guidebook is intended to help organizations take their first steps. It is based on a belief that high-quality strategic research is within reach for most institutions. Audience research does not have to be complex or costly—a modest budget is sufficient in many cases. Special skills aren't necessarily required, but thoughtfulness, careful planning, and execution according to plan are needed to obtain accurate information about an audience—and improve decision making.

Just ask the San Francisco Girls Chorus and The Clay Studio, 2 of the 10 arts institutions whose research efforts informed this guidebook. Accounts of their experiences bring audience research to life throughout the report, showing how to translate questions about a potential audience into a research project able to deliver valuable insights that will help you make inroads with that audience. To help readers accomplish the same in their own organizations, the guidebook also explains how to conduct audience research step by step by drawing upon the experiences of the 10 institutions and the market research literature.

All of the institutions received a Wallace Excellence Award (WEA), The Wallace Foundation's grant program that funded audience-building initiatives at 54 organizations in six U.S. cities from 2006 to 2014. Grant recipients represented diverse art forms and pursued their target audiences in different ways, but, as stipulated by the funding agreement, all used market research to develop their audience-building strategies and track their progress. For many, it was their first time doing research.

The initiatives of the 10 organizations featured in this guidebook were selected as case studies, which can be accessed at www.wallacefoundation.org. This report is organized around three activities that were integral to their success:

1. Learning about Audiences. Research gave organizations a clearer idea of what different target audiences thought of them and their art, and how those perceptions influenced the decision to visit or not. It also helped identify lifestyle and other factors that kept certain audiences from visiting or from visiting more often. Arts groups used this knowledge to create programs that made their art more accessible and visits more rewarding for newcomers and existing audiences alike.

2. Creating Effective Promotional Materials. As part of their efforts to build audiences, several institutions explored how new audiences reacted to their websites, brochures, and other marketing materials. Many were initially surprised by the negligible (and occasionally negative) impact some of their marketing materials had among those not already in the know, but once they understood the perspective of the new audience, they used the feedback to more effectively communicate who they were and what they could bring to people's lives. Many also determined which advertising channels and

materials were most effective and were able to save tens of thousands of dollars by jettisoning efforts that were not delivering value.

3. Tracking and Assessing Results. The organizations featured in this report did more than cross their fingers after launching their initiatives. They turned to audience research to get an ongoing and accurate read on who was visiting and why. In many cases, the research design was basic but effective, such as having staff and volunteers administer an exit survey of just a few relevant questions. By gathering this type of information, arts managers could ensure that a program was on track—or troubleshoot when it was not.

Audience Research That Makes a Difference

Research has an impact only when it helps staff members make decisions that improve their work. Finding things out about an audience without having a way to act on that information wastes time and money. The research conducted by the organizations in this guidebook was purposeful. Staff members asked specific questions that could help them make decisions or break through roadblocks. Because of that discipline, their research yielded insights and exposed clear implications that helped them strengthen their audience-building programs. Research results didn't dictate the decisions that were made, but they did figure among the other considerations, including budget constraints, staff resources, and artistic mission.

> ▶ **Audience research helps ensure that choices about engagement programs and marketing are based on knowledge, not hunches.**

It is not uncommon to face internal resistance to conducting audience research, in part out of concern that acting on research findings could compromise the organization's artistic mission. The research discussed in this report did not ask audiences what the arts organizations should create or present. Instead, it explored their reasons for not participating and tested out strategies that would pique the interest of people new to an art form. Several organizations learned that they could awaken new audiences

by presenting their work in a different venue, for instance, or with marketing programs that would show a different side to newcomers. Used in this way, research emboldens rather than constrains decision making and the fulfillment of the artistic mission.

Organization of This Guidebook

The guidebook has four chapters. The first three cover how market research can support the audience-building activities described above: learning about audiences, creating effective promotional materials, and tracking and assessing results. The fourth chapter examines how to involve internal and external partners in a research project, and why it's important to do so.

The first three chapters all begin with brief case examples of arts organizations that conducted successful market research projects. In each case, the research was set in motion because staff members couldn't answer certain commonly arising questions about a potential audience. Staff members wondered what potential visitors thought of their organizations, for instance, or whether their current marketing tactics clicked with people who knew nothing about them. Their questions prompted action on four steps, which are covered in each example:

1. Research Objectives: Staff members laid out specific objectives to improve their understanding of an audience's behaviors or perspective. The objectives included exploring new ideas, testing hunches, and assessing the impact of a program.

2. Research Plan: Staff, often in consultation with a market research professional, developed a plan to accomplish their research objectives. The plan included:

- The research method
- The research participants (whom they would interview or survey)
- The questions that would elicit information needed to fulfill the research objectives

3. Results: The organization reviewed the research findings and what their implications were for marketing and programming.

4. Acting on the Results:
The new knowledge was applied in designing and refining marketing and audience-building programs.

Following the examples, each chapter provides step-by-step instructions for conducting the most common type of market research for that particular audience-building activity. Typically, organizations that want to learn about a potential audience or improve their marketing to them do qualitative research, such as conducting focus groups. Tracking and assessing the success of an audience-building program requires quantitative research, such as a

Figure 1. Steps in Carrying Out Research

survey. The guidelines focus on these methods. Of course, there may be times when it's appropriate to do a survey to learn about a potential audience or to convene focus groups to gauge the success of an initiative. These exceptions are noted where applicable, but the guidebook concentrates on the most common type of research for each audience-building activity because it is generally the most informative choice. Organizations new to research will want to begin with those.

Research materials such as surveys and focus group guides complement the examples whenever possible, and are included in Appendix 1. They're not intended for others to simply copy and use, because the research projects were designed to fulfill the strategic goals of the organizations that are profiled. However, they illustrate the process of moving from a challenge, to a research plan, to obtaining actionable results, and can serve as a starting point for thinking about how to structure your own project.

LEARNING ABOUT AUDIENCES

Introduction When it comes to learning about the perceptions and lifestyles of an audience, arts organizations typically do *qualitative* research, such as interviews or, more commonly, focus groups. Qualitative research is popular because it is well suited to exploring ideas and discovering new things—both of which are necessary for an organization that wants to target an audience it knows little about or to engage an existing audience in a new way. While quantitative research tools, such as a survey with multiple-choice questions, provide *objective* counts or measures of something (e.g., how many visitors are first-timers), qualitative research is designed to capture the *subjective* experiences of a particular group in a more holistic way. Instead of collecting hard numbers, qualitative research lets people describe their attitudes, behaviors, and perceptions in their own words. The questions are open-ended, allowing respondents to frame their answers on their terms and from their vantage points. It may seem as if research shouldn't be so subjective, but with qualitative research, that's just the point—to gather the perceptions, ideas, and even emotions of members of a group. Those insights can then inform your audience-building initiative and the marketing you do to generate interest.

A focus group is a moderated discussion in which the interaction within the group identifies the concerns, interests, and habits the members share. In this way, a series of focus groups can reveal the range of opinions held by a target audience (e.g., "young professionals" or "non–English speakers"). They are usually managed by a professional researcher, who advises on the research design, writes the discussion guide, and moderates the groups. Each focus group lasts one and a half to two hours, and typically takes place at a facility designed for such a purpose. Participants are often, but not always, recruited by the facility.

Table 1. Qualitative vs. Quantitative Research

	QUALITATIVE	QUANTITATIVE
Type of Data	Verbal, conceptual	Numerical
Purpose	Exploration: Researchers are not sure what they are looking for	Confirmation: Researchers know what they are looking for
Question Types	Open ended "what," "how," and "why" questions	Closed ended "how many," "how often," "how much" questions
Number of Participants	Few, but in-depth conversations	Many, to produce reliable results
Typical Methods	Focus groups, in-depth interviews, ethnographies	Surveys

Based on their experience working with nonprofits, program evaluation experts Richard A. Krueger and Mary Anne Casey note that focus groups can guide decision making at three critical junctures in audience-building initiatives:[1]

1. During the development phase, to gain an understanding of how an audience perceives and values an art form and an institution—what they like, what they dislike, and barriers to and incentives for engagement

2. Prelaunch, to gauge reaction to program ideas, such as different concepts and prototypes

3. Postlaunch, to get diagnostic feedback that can identify areas for improvement

This chapter examines how three arts organizations—Pacific Northwest Ballet, Fleisher Art Memorial, and the Isabella Stewart Gardner Museum—used focus groups during the development of their audience-building programs. (Chapter 2 covers how arts groups can use qualitative research

1. Krueger and Casey do not explicitly tie these to the nonprofit arts; the author made those analogies and extensions. Richard A. Krueger and Mary Anne Casey, *Focus Groups: A Practical Guide for Applied Research—Fourth Edition* (Thousand Oaks, CA: Sage Publications, Inc., 2009), 8–9.

to create effective promotional materials for a new audience and Appendix 2 offers an example of an organization that used focus groups to improve an ongoing audience-building initiative.) By undertaking this careful and thorough research, these institutions learned what potential audiences thought of them and their art forms. They identified specific actions they could take to combat negative or inaccurate perceptions and help new audiences connect with the work they presented. Following the examples, step-by-step guidelines explain how to conduct focus group research that will provide fresh and meaningful insights about an audience.

▶ A FOCUS GROUP IS NOT A SURVEY

The greatest strength of focus group research is that it lets you go in-depth with a small group of people and obtain a rich, multidimensional view of their lives. That is also the source of its greatest limitation, and why results should be interpreted with care. For starters, the number of participants is typically small. The opinions they express are somewhat a function of not only who happens to participate but also group dynamics and the direction in which the moderator leads the conversation. Some respondents may be very articulate and express a sentiment in a compelling way—one that those observing the focus groups may have a hard time forgetting. The problem is, one or two opinions, no matter how emphatically expressed, may not reflect those of the broader audience.

Moreover, a few focus groups cannot give an accurate reading of how widely held opinions are in the overall audience. Focus group research is compelling because it can tell you the reasons why your initiative may or may not succeed and identify ways to improve it. It's a mistake to think it can gauge *how much* appeal your initiative will have. That's the job of quantitative research, such as a survey conducted with a representative sample of your audience that accurately measures their interest in a program. (See Chapter 3 for guidelines on conducting a survey.)

Case Examples:
USING FOCUS GROUPS TO LEARN ABOUT POTENTIAL AUDIENCES

Why Aren't They Coming?
Focus Groups Show Pacific Northwest Ballet How to Generate Interest among Young People

Research ▶ **The Challenge:** In the first decade of the new millennium, Seattle's Pacific Northwest Ballet (PNB) set out to buck the nationwide trend of young people turning away from ballet. The company had a reputation of excellence in classical story ballet and the work of George Balanchine, and new artistic director Peter Boal sought to both introduce new repertoire and "plant the seeds" for the audience of the future by attracting large numbers of teens and young adults to its performances. Boal saw the challenge as one of building relevance. "There are certain performing arts that young audiences *do* care about," he says. "They care about hearing a musical group. They care about certain films. I want ballet to be in that category."

Except for some reduced-price ticket promotions, PNB had not made significant overtures to young people. The marketing director at the time, Ellen Walker (now executive director), believed the company needed a stronger digital presence to reach them, given research showing that they learn about organizations primarily online. She and her staff also suspected that PNB's communications, no matter how successful they were with current patrons, could better engage teens and young adults. They were determined to improve their strategy, but to move in the right direction, they first needed to answer three questions: **Why weren't culturally active young adults and teens coming to PNB? What did they think about its marketing? What types of communication, promotions, and programs might pique their interest in its performances?**

Research Objective/Method: To answer these questions, in 2009 and 2010 PNB conducted two rounds of focus groups made up of culturally active teens and young adults and facilitated by professional moderators. The

discussions explored perceptions of PNB and of ballet itself, and how those perceptions aligned with what was important to teens and young adults when choosing cultural activities.

Here, we take a closer look at the second round of focus groups in 2010, in which participants discussed PNB's advertising and its impact on their perceptions of the company. (The 2009 focus groups elicited perceptions about PNB's website, and are described in the case study.[2]) PNB engaged a professional research firm, Strategic Action, Inc., to recruit the respondents, conduct the focus groups, and prepare a written report of the results and their implications.

Research Participants: PNB wanted to talk with young adults and teens ages 13 to 35 who were new to the company, so its in-house database of current patrons was of no use. Instead, it tapped the database of a local focus group facility to find young people in Seattle who were culturally active—and, therefore, good prospects for PNB. All participants:

- Demonstrated an active interest in cultural and leisure events by having attended at least two of the following in the past six months: live theater, a museum, a concert, a dance performance, local arts festivals, a Seattle Sounders soccer game, or a show from the Vera project, a Seattle youth arts organization
- Had not seen a PNB performance in the last year, but were open to the idea of attending a professional dance performance

In addition, at least half of the participants in each focus group had heard of PNB. The marketing staff and its research partner, Strategic Action, Inc., decided to segment the groups by age because they believed that people of different ages likely make decisions about cultural activities in different ways. They also thought that participants of the same age would relate to one another better, so participants' contributions would build on and play off of each other (for more on segmenting, see "Consider Group Dynamics" on page 37). There was one group of teens ages 13 to 17, one group of young adults ages 18 to 24, and two groups of college graduates ages 22 to 34. The last two groups were further segmented based on whether the participants had

2. Bob Harlow and Tricia Heywood, *Getting Past "It's Not for People Like Us": Pacific Northwest Ballet Builds a Following with Teens and Young Adults* (New York: Wallace Studies in Building Arts Audiences, 2015).

children. Parents often report having less time and money for cultural pursuits than nonparents, and often look for activities they can enjoy as a family. Therefore, their reasons for not attending PNB might be different from those of young adults without kids. Interviewing separate groups of parents and nonparents would allow those reasons to emerge and be explored.

> **TIP** ▶ You'll need parental permission to recruit minors for a focus group. For its research with teens, Pacific Northwest Ballet first gained permission from an adult in the household before talking to a teen to determine his or her eligibility to participate.

Questions: The moderator warmed up each group by asking about a recent live performance participants had attended, including how they had heard about it, whom they went with, and how it fit into their evening, such as before or after dinner. The two-hour conversation then moved closer to PNB's main focus—determining what had attracted respondents to a particular performance, including the roles of price, promotions, and other elements driving choice. They were also asked about online and offline sources of information.

As the discussion progressed, group members gave their impressions on dance, PNB, and the degree of their interest in attending a performance. They talked about what had prevented them from going to PNB and how those barriers might be overcome. PNB wanted to explore new ways to introduce the company to young people that would attract their attention and build sustained interest. The group brainstormed ideas and also reacted to some hypothetical promotional offers and events, such as having PNB dancers perform at an all-ages dance club with a popular alternative rock band.

The focus groups also spent considerable time discussing offline and online advertising. Participants first recalled examples of advertising they liked, then turned their attention to PNB's recent brochures and website. They spent a few minutes quietly reviewing the materials before discussing them among the group, so their reactions would be less likely to be influenced by what others thought.

Results: The research identified two broad areas that PNB would need to address in order to attract young people.

1. Challenging Stereotypes about Ballet. When focus groups discussed what they look for in cultural activities, they described affordable, relaxed, social experiences where they knew something about the performers. PNB met none of these criteria, according to participants. Teens and young adults assumed ballet tickets were expensive, and possibly difficult to obtain. That was somewhat of a screen, though; when pressed, participants said they would pay a moderate price to see a performance they knew they would like. However, that was unlikely to happen because they knew absolutely nothing about PNB or its artists (recall that PNB recruited participants who hadn't been to one of its performances in the past year). It wasn't that focus group participants had something against ballet, but rather, as one respondent succinctly put it, "fear of the unknown." Without firsthand experience, they imagined that the ballet would be little more than boring swan arms (which they mimicked) and slow movements. They thought the audience would be older, spontaneously referencing the stuffy TV character Frasier Crane, also from Seattle, as a typical attendee. These vivid descriptions helped PNB staff understand on a deeper level why young adults thought the ballet was not a place for them.

Focus groups reacted very positively to promotional ideas—and even suggested some of their own—that brought ballet out of the performance hall and challenged the ballerinas-in-tutus stereotype. While PNB wasn't necessarily prepared to implement these promotions at face value, the feedback confirmed that young people were open to the idea of taking ballet out of its traditional context. The proposal to put ballerinas on stage with a rock band, for instance, surprised them and made them think differently about the art form.

2. Advertising in Ways That Speak to This New Audience. According to the research, young people went online to get logistical information and learn more about the performers and venue before committing to a particular cultural activity. Those details typically were easy to find for venues they frequented, but not for PNB. Without that context, participants found it difficult to picture themselves at PNB. They couldn't imagine how an evening at the ballet would unfold (e.g., the length of the performance, what the

intermission would be like, etc.). Indeed, the focus groups said they rarely saw or heard ads for PNB in the media outlets they favored, such as online listings or alternative newspapers. One participant mentioned hearing an ad for the ballet once after "flipping on the classical music station for a couple of minutes." They did recall seeing ads for *The Nutcracker* during the holiday season, but since these ads tended to look the same every year, the respondents assumed that PNB always did the same productions.

PNB's advertising did little to shake the focus groups' impressions of ballet as a beautiful but static and unengaging art form. The ads, such as the one on the left in Figure 2 and in Colorplate 1, favored a dark color scheme and had little or no promotional copy. Many featured full-body shots of dancers on stage that showed their physical prowess, but not necessarily their emotions—creating a psychological distance that failed to pull in the focus groups. Typical comments included:

- "It's just boring. It's like a muted color, backdrop of somebody in a weird pose."
- "It's a very traditional ballet-looking picture to me. It's something that didn't necessarily make me want to see the show, so I didn't even bother reading the text. The picture has to be eye-catching first, and make me want to read what it has to say."
- "Not only do they look like they're in pain … but the colors…. It's beige on black, it's brown on black, it's beige-brown on black, or it's black and white. I like color."

Some of the photographs also reinforced unhelpful stereotypes. Images of dancers wearing diamond tiaras and tutus made focus group participants think of ballet as elitist and expensive. The lack of information about ticket prices also led respondents to assume that they wouldn't be able to afford them. The ads may have worked with existing audiences who knew what to expect when attending the ballet, but they failed to interest potential newcomers.

The focus groups said they were moved more by advertising that, in the words of one participant, "looks like advertising." Indeed, they reacted positively

when shown bright, bold advertising that showed the emotion on the dancers' faces. It challenged their expectations and signaled something new.

Acting on the Results: PNB wasn't surprised that teens and young adults thought ballet was boring and stuffy—it had heard those sentiments in its first round of focus groups. While it wasn't easy to hear such negative comments, PNB remained mindful that they were just perceptions and not based on actual experience or reflective of how the company really was. Nevertheless, the organization realized that it had to challenge those stereotypes, which the focus groups demonstrated were robust, if it was to succeed in attracting more young people. Given how little young adults knew about PNB and their inclination to see performances where they were familiar with the venue and artists, Walker and her team pushed forward with overhauling the company's website. They produced a broad and deep range of digital content, including videos featuring its dancers (mostly young adults), to help potential audiences get to know the company and provide an idea of what a performance would be like.

Figure 2. Advertising for Pacific Northwest Ballet
Before Focus Groups After Focus Groups

 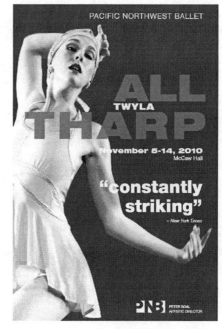

The research also led the marketing team to rethink its communications strategy and experiment with new ads that tried to dispel notions of ballet as boring and stiff. They added more close-up photos of dancers to show their emotions and used a more vibrant color scheme (see Figure 2, right and Colorplate 2). Often the ads included pricing information that young audiences said they wanted to see (e.g., *Tickets start at $25!* or *Up to 40% discount on tickets!*).

PNB's revamped marketing supports a broader initiative to attract young people through new promotions and programs. The results so far have been very positive. Between the 2008–2009 and 2012–2013 seasons, PNB's ticket sales to teens more than doubled and ticket sales to young adults ages 18 to 25 rose 20 percent. Those audiences have continued to grow.

Cost: Between $25,000 and $30,000 for four focus groups. This included the fees for the research firm that designed and moderated the focus groups and wrote a report based on its analysis of the proceedings. It also included the rental of the facility where the focus groups took place, the recruitment of participants, and their incentives.

Research Materials: Please see Appendix 1 for the screening questionnaire used to recruit participants for PNB's focus groups and the focus group discussion guide.

The teens and young adults in Pacific Northwest Ballet's focus groups were recruited by a professional research company pulling names from its database. It wasn't complicated because culturally inclined people are plugged in to a lot of organizations and tend to show up in such databases. In addition, there are many culturally active young people in metropolitan areas such as Seattle. Qualitative research with a new audience that's hard to reach or few in number, however, is not as easy. But it's not impossible with creativity and a bit of elbow grease, as Fleisher Art Memorial discovered in the example that follows.

How Can We Become Relevant?
Fleisher Art Memorial Gets Time with Hard-to-Reach Audiences and Learns How to Connect with Them

Research ▶ **The Challenge:** Fleisher Art Memorial is a community-based arts organization in South Philadelphia. It was started by industrialist Samuel S. Fleisher at the turn of the 20th century to provide free art lessons for the children of factory workers living in the neighborhood. He believed that a democratic society is strengthened when people of different backgrounds create art alongside each other. With the new millennium, the demographics of Fleisher's neighborhood shifted radically, with newly arrived immigrants from Latin America and Asia replacing the predominantly European-based communities of decades past. Fleisher served many of these new arrivals in off-site programs that taught art to children in public schools and to people of all ages in community centers. The staff noticed, however, that these same individuals weren't coming to on-site classes and programs, which tended to draw more white, affluent visitors from outside the neighborhood. This divide concerned the organization because it contradicted the founder's vision of bringing together people of diverse backgrounds.

To rectify the situation, the staff started to develop several on-site programs that they hoped would appeal to neighborhood residents, particularly recent immigrants and first-generation Americans. Their ideas included a full-day summer camp, free family workshops on Sundays during the school year, and an after-school arts program. Preliminary research[3] conducted with community leaders and current students from the neighborhood to refine their plans revealed something much more concerning: No matter how much Fleisher was admired by its existing students, it lacked goodwill among newly arrived immigrants in the neighborhood. Frankly, even though many of them

3. That preliminary research was managed by Fleisher's research partner, Slover Linett Audience Research, and included focus groups with students, interviews with neighborhood community leaders, and an ethnography exploring the needs and perceptions of immigrant, African American, and low-income neighborhood residents with respect to what Fleisher can and does provide. Details are available in the upcoming case study in the series of Wallace Studies in Building Arts Audiences, *Staying Relevant in a Changing Neighborhood: How Fleisher Art Memorial Is Adapting to Shifting Community Demographics.*

valued the arts, these newcomers didn't know or care what Fleisher was. To them, Fleisher seemed to offer a Western European approach to art that had little relevance to their lives. Fleisher could build the programs, but it was unlikely that large numbers of its target audience would come. **How could Fleisher develop both awareness and trust with an audience that wasn't thinking about it at all?**

Research Objectives: Fleisher wanted to identify how its communications, visitor services, and programming could engage and build relationships with groups in the surrounding neighborhood who were not yet visiting the school. This included not only members of immigrant populations but also low-income and African American households. To do so, it needed to examine:

- The role of art in residents' lives
- Awareness of and perceptions about Fleisher
- Barriers to participation
- Motivations to participate that Fleisher could leverage

Method: Fleisher engaged Slover Linett Audience Research to conduct four, 90-minute focus groups with a total of 27 adults living in the two ZIP codes immediately surrounding it. The groups were segmented by ethnicity to create a more comfortable and familiar atmosphere and to reveal concerns specific to certain groups. They included one with Asian residents, one with Latino residents (conducted in Spanish), and two with mixed ethnicities, including African Americans.

Research Participants: Fleisher knew recent immigrants and low-income residents would be tough to get into focus groups. Many of them are wary of outside organizations, and they certainly don't show up in the databases of most professional research firms, making recruitment a challenge. The problem was exacerbated by the fact that Fleisher was targeting a relatively small geographic area, not the entire city of Philadelphia. Such narrow parameters would even make it difficult to recruit African Americans, whose families had been there for generations. Researchers refer to these kinds of target audiences as "hard to reach" because simply finding and talking to a modest number of them for research purposes is a challenge.

But Fleisher didn't give up; instead, it got creative and reached out to three community organizations it had existing relationships with to serve as ad hoc

recruiters. Its research partner, Slover Linett Audience Research, coordinated the process and developed a simple one-page questionnaire that the community organizations used to recruit potential participants. The screening process wasn't as rigorous as it typically is, but the questionnaire did capture basic information such as name, address, age, ethnic/cultural identification, and preferred language. Slover Linett also created a tip sheet with recruiting guidelines (e.g., "Do not fill the groups with family and/or friends in the interest of obtaining diverse opinions"). Again the idea was to provide easy-to-use, yet effective instructions. Each community group recruited 8 to 10 participants from its own contact lists. The focus group sessions were held at community centers rather than at a traditional focus group facility as an added measure to help participants feel comfortable in a familiar setting.

Fleisher's informal recruitment process wasn't without problems. Perhaps the biggest was confirming the attendance of all the participants in advance of the focus groups. While this is necessary to ensure that groups have enough participants, it became time-consuming because of the dispersed method used for recruiting. Nonetheless, the technique worked: Fleisher staff described the focus groups as engaged, interested, and opinionated.

Questions: Based on earlier discussions and research, staff members suspected that Fleisher had both an image and a relevance challenge. Few of the neighborhood residents it was targeting knew of it, and they had little connection to the Western-based art that Fleisher taught. Like Pacific Northwest Ballet, Fleisher was looking to diversify its audience. Doing so would require understanding the psychological divide that neighborhood residents saw between Fleisher and themselves. The research team also wanted to explore potential practical barriers, such as a lack of time, money, or childcare. Led by a moderator, the conversation was designed to flow easily from topic to topic:

- **Art making in their lives:** After basic introductions, the moderator asked the group members about their art-making activities, including classes or community activities, and the role of art in their lives.
- **Perceptions of Fleisher Art Memorial:** The conversation quickly turned to Fleisher and what people had heard about it. Participants were asked to review Fleisher's course catalog, its main piece of marketing content that's distributed four times a year to announce each

season's classes. The moderator examined both the perceptual and the practical, first exploring participants' impressions of Fleisher based on the catalog and then the extent to which the course descriptions were clear and the registration forms looked easy to complete.

- **Language as a practical and psychological barrier:** The Latino and Asian groups discussed whether the English-only format of the course catalog was difficult or frustrating. That led to a series of questions in which the two groups imagined Fleisher-specific situations where a lack of English skills could be a deterrent, such as calling for information (encountering both a live operator and a recorded menu), navigating the building, and taking classes taught in English.

- **The on-site experience:** As the conversation reached its halfway point, the moderator asked respondents what they expected a visit to Fleisher to be like. This was a way to surface hidden assumptions that, while not based on experience and perhaps not reflective of what happens at Fleisher, influence the decision on whether to attend. The group described the kinds of instructors they would want, the kinds of fellow visitors who would make them feel at ease, and which art-making traditions they would hope to see in the classes. They discussed their preferred class format (e.g., once a week over a few weeks vs. one-day workshops). The moderator raised practical considerations such as transportation and childcare to gauge how important they would be in enabling visits to Fleisher.

- **Off-site overtures:** Since Fleisher wanted to raise its visibility in the neighborhood, it asked about places and events where it could have a presence, such as local churches, community centers, or festivals. Several ideas were thrown out in order to prompt the group's suggestions.

- **Children and families:** Fleisher knew from previous research that children were an important population to serve because parents are always looking for enrichment activities. Participants with kids were asked how inclined they were to enroll them in Fleisher classes. The moderator raised potential logistical barriers, such as childcare before or after class, to weigh their significance.

- **Communications:** The discussion concluded by asking participants

if they would be willing to visit Fleisher (and/or to send their children, if they had any), and why. Finally, they discussed how Fleisher could get the word out to the community: Who would be a trusted messenger? What types of communication should Fleisher use? How else could it spread the word?

Results: The focus groups corroborated previous research that found that Fleisher's target audience knew very little about it. What's more, both perceptual and practical barriers stood between these neighborhood residents and the organization. Instead of feeling welcome, many in the surrounding community saw Fleisher as an exclusive institution for people with leisure time who wanted to pursue a Eurocentric approach to art making. It had limited relevance to their interests because they didn't share that heritage.

While it might be possible for Fleisher to dispel those misperceptions by adding classes that reflect the community's diverse cultures, it also faced practical barriers that were in some cases almost insurmountable. These included the very real time constraints on adults working long hours at multiple jobs, cultural or geographic isolation exacerbated by poor transportation options, and language barriers that often made even the registration process impossible for those who might consider Fleisher.

In its analysis, research partner Slover Linett examined the comments individually and in their entirety to discern how Fleisher could build trust and relevance among community residents. Three themes emerged in different ways throughout the discussions, and Slover Linett distilled them into a strategy from the vantage point of focus group respondents:

- **Come to us:** Community members wouldn't approach an institution that, from the outside, appeared elitist and Eurocentric. Many didn't explore much beyond their immediate neighborhoods, anyway. For those reasons, Fleisher had to make the first move. It needed to introduce itself to the community in familiar settings, such as festivals and other public events. It should advertise in local newspapers, including those in foreign languages, to demonstrate its interest in reaching those populations.
- **Show us:** Neighborhood residents didn't get what Fleisher does, and the course catalog didn't speak their language—it was wordy and

filled with terms unfamiliar to English language learners and people with limited experience in the kind of art Fleisher teaches. They needed clearer, more accessible information about what Fleisher is, the programs it provides, and how to access them. The catalog should include detailed scheduling information, which is critical for time-strapped students, and fully explain the tuition-assistance process in nontechnical terms. Written descriptions of the courses might fall flat; photographs and actual demonstrations of the art would provide a better sense of what to expect in the classroom.

- **Welcome us:** It wasn't enough to attract neighborhood residents; to encourage repeat visits and greater involvement, Fleisher needed to provide a friendly, accommodating, and respectful experience. The Fleisher building can itself be intimidating, and newcomers can quickly come to feel that it is not their place—particularly when language is also a barrier. Fleisher staff should at least make an effort to be patient and attempt to work through the language difficulties.

Acting on the Results: According to Fleisher's director of programs, Magda Martinez, "come to us, show us, welcome us" has become a "strategic compass" guiding the organization's engagement strategies with the neighborhood.

Take, for instance, its approach to neighborhood ethnic festivals. Rather than just distributing brochures at an information table, staff members help kids make culturally relevant art. The institution has also launched an artist residency in a local park and ColorWheels, a mobile art studio that runs mini workshops around the community. It's expanded its own annual street fair to include more local vendors, performers, and residents. This involvement with the community shows Fleisher's commitment to it *and* gives people a chance to experience what it's all about.

The organization is also laying out the welcome mat when newcomers step through its doors. It added a Visitors Services department to assist people and make them feel welcome when they visit or call for information about Fleisher's programs. A new training program familiarizes staff with the organization's community engagement initiative and how to interact more effectively with visitors of diverse backgrounds.

▶ IN THEIR OWN WORDS

Fleisher's research partner, Slover Linett Audience Research, analyzed the focus group discussions with community residents and found three broad themes: come to us, show us, and welcome us. The comments of focus group participants bring those themes to life:

■ Come to us: We can get to you, but we'll be more comfortable starting a relationship if you come to us.

- Community residents feel intimidated.
 - o *Sometimes we might see the building and be afraid to go in there; we don't know if anyone will talk to us; we don't want to go. But if you come to us, that would give us more confidence to approach you. (Female, Latino group)*
 - o *Even though [Fleisher] seems really close on the map, it's really worlds apart. (Male, Mixed group)*
- Fleisher staff must introduce themselves to the community at established gathering places and events.
 - o *Pass the word, go down to the community centers and do demonstrations and teach art and get them involved. Tell them about the multitude of programs that you have at Fleisher and have your name reverberate throughout the community. (Male, Mixed group)*

■ Show us: Don't tell us what Fleisher does, show us what you're all about.

- o *You obviously can't cover every single language that's out there, but visuals are really helpful. Even reading some of this, I don't really know what "Explorations in pointillism" is. We need to not just read it, but see it. (Female, Mixed group)*
- o *Show the art. Because if I told her silk-screening, she might not know what silk-screening is. (Female, Mixed group)*

(continued on next page)

■ Welcome us: We want to feel comfortable at Fleisher. In addition, the realities of our lives make it difficult for us to take part.

- Latinos and Asians find that the language barrier becomes a psychological one; respondents aren't saying staff members need to speak their language, but their attitude needs to be welcoming even when communication is difficult.
 - o *Sometimes receptionists are friendly and they see that you're a little worried and they say, "Okay, don't worry, look ... " and they help you understand. But there are other receptionists who see that you don't speak English, and [pretend] they don't see you and they don't help orient you. (Female, Latino group)*
 - o *At the very least speak in slow tones and in a way that would get them to understand, get them to know you care. (Male, Mixed group)*
- Language can also be a practical barrier that simply prohibits access.
 - o *Even if they have a lot of questions, they just give up. If somebody just keeps talking English to them, they'll just hang up the phone. (Female, Asian group)*
- The cost of Fleisher classes is a barrier to many—lower income and newly arrived neighborhood residents are focused on economic survival, not discretionary spending for art. Fleisher should highlight its financial assistance.
 - o *$45, I can do something better than coming to this. I could put food on the table for my children. (Female, Mixed group)*
- Many community members work non-traditional hours or multiple jobs, so they would benefit from flexible class schedules.
 - o *My schedule is a mess. It's not every Tuesday I'm available in the morning. That's why I hesitate to take these classes. I don't have [consistent] time for it. (Female, Asian group)*

These are only a few ways that Fleisher has delivered on "come to us, show us, welcome us." So far, its efforts have been well received. An audience tracking survey has found that Fleisher is now seen more as a place that celebrates diversity and its community than it was just a few years ago. And a much larger percentage of students in its on-site classes for children now come from its South Philadelphia neighborhood.

Cost: $24,000 for four focus groups, including recruiting supervision, moderating, and report writing

Research Materials: Please see Appendix 1 for Fleisher's tip sheet for community organization partners, focus group participant form, and focus group discussion guide.

How Do We Get Audience Input If We Can't Afford Focus Groups?
The Isabella Stewart Gardner Museum Learns How to Appeal to Young Adults by Asking Its Own

Research ▶ Focus group research may be out of reach for organizations with limited budgets. However, it's still possible to learn about an audience, explore their perceptions, and surface programming ideas through more informal (and less costly) discussions managed and led internally. To be most useful, these discussions should be planned with the same rigor as formal qualitative research. They should have a clear sense of purpose and structure—it helps if someone on the team has been through the process before. As with formal focus groups, these discussions work best when the groups' members have similar backgrounds, lifecycle stage, or other experiences that help them relate to each other and paint a portrait of the target audience. The Isabella Stewart Gardner Museum took just such a shoestring approach to test and develop ideas for an event targeting young adults. Its efforts paid off handsomely.

The Challenge: At the turn of the 20th century, wealthy art patron Isabella Stewart Gardner built a museum in Boston to house her eclectic collection of more than 2,500 paintings, sculptures, tapestries, furniture, and rare books.

In 2007, the Gardner Museum took on a challenge familiar to many organizations: Find ways to engage young adults. The staff believed that 18- to 34-year-olds were crucial to the Gardner's long-term viability and set out to create a monthly event that would appeal to them. They envisioned an after-work event where attendees would interact with each other and the collection, in the same spirit of the art salons the museum's founder had hosted during her lifetime. The evening would take advantage of the Gardner's atmospheric courtyard for music, refreshments, and conversation, while its intimate galleries remained open for exploring the art.

This was an entirely new tactic for the museum. It had never been open in the evening or targeted this specific audience before. Staff knew of other institutions that had drawn young people to social events after work, but they had less luck getting attendees to engage with the art. Often, the art got lost. Staff quickly realized that they needed to answer two questions if they wanted to be successful: **How could they create an event based on their vision that would draw young adults? How could they get the word out?**

Research Objective: The staff's objectives were twofold—to test ideas and to generate new ones for event programming and promotion.

Method and Research Participants: Peggy Burchenal, the museum's curator of education and public programs, and Julie Crites, then director of program planning, ran three discussion groups, each with about 10 museum staff and volunteers who were 18 to 34 years old. Two groups consisted of staff from several departments, including visitor services, the box office, different curatorial areas, and security. The other group was comprised of young museum volunteers. Each two-hour discussion was held in a conference room at the end of a workday, with pizza and refreshments. Crites reports that participants were happy to take part—they seemed genuinely flattered that their opinions were being solicited, and said they found it fun.

Questions: Burchenal had considerable research experience, so she and Crites worked together to design a formal agenda and discussion guide for the groups. They outlined the topics to cover, how much time to spend on each one, and how the conversation would flow. Crites—a member of the 18- to 34-year-old demographic herself—led the groups through a discussion of the following topics:

- The kinds of events they and their friends gravitate toward and enjoy on weeknights
- A preliminary sketch for Gardner's after-work event and initial ideas for activities it might offer
- Suggestions and commentary from the group on how much they and their friends might enjoy the activities and find the event an appealing way to socialize after work
- Brainstorming additional programming ideas for the event
- How participants heard about events around Boston
- Brainstorming ways to publicize the new program
- Potential names for the event (a follow-up discussion with one participant led to the name *Gardner After Hours*).

Crites followed general principles of brainstorming throughout the discussion—e.g., there were "no bad ideas." As the group made suggestions, she wrote them on Post-it notes to stick on the wall for all to see, react to, and build upon.

Results and Actions Taken: Group participants emphasized that the event should be highly social. When they went out on weeknights, they wanted an atmosphere that was markedly different from the one they just left at work. Staff members took that insight and hired DJs and live musicians to play at *After Hours*. They also set up a bar serving beer and wine in the courtyard. Staff wanted attendees to peruse the collection in the galleries—and not park themselves at the bar—but realized that young adults looking for a social night out were unlikely to take an hourlong tour with a docent. Instead, they designed shorter, informal talks in the galleries led by young volunteers who encouraged conversation among visitors. Based on feedback from the discussion groups, the staff also stationed younger volunteers throughout the museum so visitors would see people who looked like themselves.

Not surprisingly, the discussion participants said they relied on social media and alternative media to learn about things to do in Boston. That feedback encouraged Gardner staff to move forward with a new strategy to reach this digitally savvy demographic group. They launched a text-messaging and social media campaign to promote *After Hours* and advertised in Boston's alternative newspapers. They also deployed "street teams" to distribute

business card-sized promotional materials at social and sporting events popular with young people.

After Hours succeeded in both drawing high numbers of young adults and creating an enjoyable experience that engaged visitors with the art. Those results were confirmed by audience research detailed in Chapter 3 on page 72, *"Are Our New Programs Attracting and Engaging New Audiences?* The Isabella Stewart Gardner Museum Uses Visitor Survey Data to Build on Success."

Costs: The out-of-pocket costs were minimal, amounting to a few bills for pizza and beverages. However, the research took considerable staff time—much more than for focus groups run by professionals—because Burchenal and Crites did all the work themselves. They wrote the discussion guide, recruited the participants, moderated the groups, and wrote up the results. At times, the project felt like an additional part-time job. It was essential for Crites and Burchenal to create time in their schedules for those activities.

The extra work is not the only caveat when doing research in-house. Some staff members might assume that a potential audience will think or behave like the patrons they are used to working with, making it difficult for them to keep open minds and see the organization from a newcomer's perspective. It's also best to steer clear of topics that are sensitive or politically charged. Staff with a vested interest might find it hard to set aside their biases, despite their best intentions. Moreover, research projects may face credibility challenges when staffers who are not experienced research professionals carry them out.

Guidelines for Using Focus Groups to Learn About Audiences

Guidelines ▶ As Pacific Northwest Ballet, Fleisher Art Memorial, and the Isabella Stewart Gardner Museum discovered, focus groups can expose the most important obstacles keeping people from visiting an arts organization and surface strategies to overcome them. Their research also provided solid guidance on how to build interest among newcomers.

The following guidelines explain how to conduct focus group research that will unlock new insights about a potential audience.

1. Set Research Objectives

You likely have a laundry list of questions about a potential audience. There could be many reasons why people are not visiting your organization that a successful audience-building initiative will need to address. How do you know which areas to focus on? In the RAND Corporation's *A New Framework for Building Participation in the Arts*, arts researchers Kevin F. McCarthy and Kimberly Jinnett provide guidance for thinking about which barriers to

▶ WHAT'S A FOCUS GROUP FACILITY?

Focus groups are typically held in a specially designed *focus group facility* that has an observation room where the research team and interested staff members can watch the discussion from behind a one-way mirror. Facility staff members organize logistics, recruit participants, confirm their attendance in advance, and greet them when they arrive.

The facility may also have moderators, but their quality can vary widely, so it's best to hire your own independently (finding the right partner is an important decision, and guidance is provided in Chapter 4). Consult the *GreenBook* (www.greenbook.org) or *Blue Book* (www.bluebook.org) to find a facility near you, but be advised that both directories include only those that pay to be listed, and they are not exhaustive.

target. Based on a review of research literature and scores of audience-building programs, they place audiences into one of three groups depending on their current commitment to the arts (see Table 2).[4] A *disinclined audience* has little interest in an organization or its art. They're likely keeping their distance because of *perceptual* barriers. They might believe an art form has nothing to offer them or that they'd feel out of place in a venue such as an opera house, gallery, or museum. Since their mindset differs from that of current patrons, attracting them would *diversify* the composition of an audience. In this context, diversifying doesn't mean a demographic change, such as in age, ethnicity, or gender, but rather attracting people who have different attitudes toward the arts than current audiences do.

An *inclined audience*, meanwhile, sees value in participating in an art form, but isn't currently doing so. RAND's *New Framework* posits that *practical barriers*, such as a lack of money, time, or transportation, are likely keeping them away. People who are inclined to participate probably have a lot in common with current visitors. At a minimum, they share the belief that art is rewarding. Targeting them would *broaden* an audience because they're similar to those who already participate.

Finally, there is an organization's *existing audience*. According to the *New Framework*, arts groups can *deepen* the involvement of current patrons (i.e., get them to visit more often) by making their experience more satisfying in some way.

The results achieved by the organizations whose work appears in this guidebook were consistent with this approach. Even if they did not explicitly reference the *New Framework*, they found that addressing perceptions was the key to attracting disinclined audiences, removing practical barriers boosted participation among inclined audiences, and improving the experience could increase visits from existing audiences.[5]

4. The *New Framework* discusses a person's proclivity to engage in the arts *as a whole*. We believe the model is most useful if it is used instead to consider a person's proclivity to engage in specific arts, simply because people are not predisposed to engage equally in all art forms. The full report, *A New Framework for Building Participation in the Arts* (Santa Monica, CA: RAND Corp., 2001), is available at http://www.wallacefoundation.org/knowledge-center/audience-development-for-the-arts/key-research/Documents/New-Framework-for-Building-Participation-in-the-Arts.pdf.

5. For a review, see Bob Harlow, *The Road to Results: Effective Practices for Building Arts Audiences* (New York: Wallace Studies in Building Arts Audiences, 2015). http://www.wallacefoundation.org/knowledge-center/audience-development-for-the-arts/strategies-for-expanding-audiences/Documents/The-Road-to-Results-Effective-Practices-for-Building-Arts-Audiences.pdf.

Table 2. Alignment among Target Audience, Goals, and Relevant Factors per RAND's New Framework

TARGET AUDIENCE	AUDIENCE-BUILDING GOAL	RELEVANT FACTORS
Disinclined	Diversify	Perceptual
Inclined	Broaden	Practical
Current	Deepen	Experience

Source: Kevin F. McCarthy and Kimberly Jinnett, *A New Framework for Building Participation in the Arts* (Santa Monica, CA: RAND Corp., 2001).

Table 3 lists broad questions that the *New Framework* suggests organizations need to answer in order to build participation among disinclined, inclined, and existing audiences. They not only can stimulate thinking about research objectives but also help later on, when developing questions to ask focus groups.

Pacific Northwest Ballet considered questions like these when it set objectives for its focus groups with teens and young adults. Based on survey data and anecdotal evidence, the company believed that young people were a disinclined audience and reasoned that it would have to change their thinking about the company and ballet in general to win them over. With that aim, it developed the following research objectives:

1. Understand young people's perceptions of ballet and PNB
2. Determine how young people decide whether to participate in a leisure or cultural activity
3. Learn how young people hear about cultural activities
4. Get reaction to PNB marketing materials and how they contribute to perceptions of the organization
5. Explore ideas for alternative programs, such as events held at nontraditional venues or set to contemporary music, that could challenge young people's perceptions of PNB

The questions in Table 3 are just a starting point. In setting research objectives, you'll also want to consider what your organization already knows about the target audience, as well as existing audience research available from service organizations or other sources, so your research doesn't cover the same ground. Membership databases and box-office receipts also might offer indications about their tastes and preferences.

Table 3. Questions about New Audiences

Disinclined audience (perceptual barriers)

■ What does this audience know (or think they know) about our art form and us? How does that align with their tastes and preferences for spending cultural and leisure time?

■ Does this audience find meaning or value in our work? Could they? What benefits, if any, do they see in participating?

■ How does this audience typically hear about cultural events?

■ Do our website, brochures, and other marketing materials interest them? What messages do they send?

Inclined audience (practical barriers)

■ What does our organization compete with for cultural and leisure time? Are we competing for limited time, money, or something else?

■ What makes our organization inaccessible (e.g., lack of childcare, parking, or transportation; inconvenient opening hours; high ticket prices)?

■ What programming best fits their lifestyle and schedules?

■ What types of experiences does this audience like—e.g., social, individually focused, family oriented? How does that compare to their perceptions of our art and organization?

■ How do they find out about cultural activities?

Existing audience (experiential factors)

■ What kinds of experiences does this audience want? What motivates visits?

■ What do they think about current programming? Does it meet their expectations?

■ How satisfied are they with diverse elements of the experience and atmosphere, as well as with logistics such as transportation, parking, and comfort at the venue?

Adapted from Kevin F. McCarthy and Kimberly Jinnett, *A New Framework for Building Participation in the Arts* (Santa Monica, CA: RAND Corp., 2001).

2. Develop the Focus Group Discussion Guide

Focus group discussions tend to be open-ended, with a moderator leading participants through a list of questions called the focus group *discussion guide*. The moderator creates the guide beforehand, usually with input from a research team that includes the organization's staff. (For more on selecting and working with a market research professional, see page 111.) Questions are grouped by topic, with time estimates for each to keep the discussion on track, and arranged in a sequence that's designed to let the conversation flow

▶ THE FLOW OF THE FOCUS GROUP DISCUSSION

The moderator doesn't necessarily ask questions in the order that they appear in the discussion guide. The idea is to introduce a topic and, as much as possible, let the conversation go in whatever direction the group takes it with the moderator steering it at appropriate times to ensure that the key topics are covered, and probing with follow-up questions to more clearly understand group members' perspectives. Because the research team and interested staff members can watch the discussion through a one-way mirror, they can request follow-up questions as topics emerge during the conversation. This is usually kept to a minimum, so as not to disturb the moderator's concentration while conducting the groups.

It's also important to create an atmosphere conducive to conversation and self-disclosure. As Krueger and Casey note, "Focus groups work when participants feel comfortable, respected, and free to give their opinion without being judged."[6] To foster that environment, the moderator does not comment on what people say (beyond encouraging them to comment) or offer his own views. Instead he remains impartial, even when participants say things that are not true. False statements may be important data! If someone wrongly states, "Tickets to the theater are expensive, they start at $50!" the moderator probably won't correct him, instead treating it as an important avenue for further exploration. He might ask, in an inquisitive, nonconfrontational way, where the participant heard this and question what others in the group have heard about ticket prices.

[6] Krueger and Casey (2009), 4.

naturally (see sidebar, *The Flow of the Focus Group Discussion,* for more on the discussion flow). To get the conversation humming, the moderator starts with "warm-up" questions that are both engaging and easy to answer. Then, the discussion moves on to questions that are more germane to the research objectives. Returning to the Pacific Northwest Ballet example raised earlier, Table 4 shows how the company translated its research objectives into relevant questions for its focus groups with teens and young adults.

As the example from PNB shows, the actual questions asked in a focus group depend on the research objectives. That said, focus groups with potential audiences often explore the following topics:

1. Current cultural and leisure activities attended by participants
 • This line of questioning is a good warm-up because it's easy for people to answer and can make them feel comfortable (starting with something unfamiliar may establish a silence that is hard to break). At the same time, these questions reveal how they go out—with friends or family, on the weekends, etc.—and can lead into a conversation about what they're looking for in cultural and leisure pursuits.

2. Perceptions of the art form
 • Have participants heard of it? What have they heard and from whom? What images do they associate with it?

3. Awareness of the arts organization
 • Have participants heard of it? What have they heard and from whom? What images do they associate with the organization?

4. Reasons for not visiting
 • Prospective audience members often mention finances or time, even when they make time or are willing to spend money for things that they know and like. Moderators often try to identify any mental roadblocks, such as a lack of awareness of or perceptions about an organization and/or the work it presents.

5. Beliefs and expectations about what a visit would be like
 • This line of inquiry often asks respondents to imagine visiting in order to surface perceptions and preconceptions that could be getting in the way. It can include such questions as: Who else would

Table 4. Translating Research Objectives into Focus Group Questions—An Example from Pacific Northwest Ballet

RESEARCH OBJECTIVE	FOCUS GROUP QUESTIONS
■ Understand teens' and young adults' perceptions of ballet and PNB. ■ Understand the benefits, if any, that they see in attending a dance performance.	■ Tell me whatever you know about when, where, and with whom you might see a dance performance. What would you do before and after? ■ What's your impression of dance performances? Describe the atmosphere, audience, cost, and any other factors that describe dance performances. ■ What are your impressions of Pacific Northwest Ballet?
■ Identify the criteria that young adults and teens use to decide whether to participate in a cultural activity. Determine whether PNB fits those criteria.	■ What interests you in a performance? ■ What might interest you in attending a PNB performance? ■ Why wouldn't you be interested in attending one?
■ Identify key sources of information about cultural events and performances.	■ Where do you hear about cultural events or performances?
■ Get feedback on PNB's website, brochures, and other marketing materials and how they contribute to perceptions of the organization.	■ What's your general impression of PNB from looking at these materials? Does that match your perception of them? Describe. ■ Was there anything that surprised you either positively or negatively? [If yes:] Describe. Does that change your opinion of PNB in any way? ■ What would make you decide to attend one of these performances? ■ What other information would you like to know? Why is that important?

Courtesy Pacific Northwest Ballet and Strategic Action, Inc.

be there? Would you see others like yourself? How much would it cost? How would you feel when you arrived? What would happen at the visit?

6. Reactions to marketing materials (see also Chapter 2, "Creating Effective Promotional Materials")

 • Respondents look at samples from the organization and others like it to answer questions such as: What attracts your attention? Is it inviting? What does it tell you about the organization? What doesn't it tell you that you would need to know in order to decide if or when to visit?

This is hardly an exhaustive list. Developing the topics to explore is one area where a trained and experienced moderator who also understands your organization and its environment can be helpful.

3. Recruit the Right Participants

In the case of a new audience, you'll obviously want to talk to people who represent the groups or group that you wish to target, particularly those that you don't know much about and are new to your organization. That could be young professionals, parents of young children, or another group that you define. Some audience prospects will be more promising than others—that is, not everyone who's not currently visiting your organization is likely to be swayed into thinking they should. Audience-building efforts are often aimed at the most promising prospects within a group. PNB, for example, targeted teens and young adults who already attended other art forms or cultural venues, but not PNB. Focus group research can target these people by recruiting respondents with a history of participating in other art forms and who would also be open to the idea of visiting the organization.

Such individuals, however, are unlikely to show up in your database or mailing list because they're not current visitors. Focus group facilities and recruiters can find qualified candidates by tapping their databases of people who are willing to participate in focus groups.[6] (See the sidebar on page 29

6. Some hard-to-reach individuals may not show up in these databases, but it's still possible to find and recruit them for a focus group. One such example comes from Fleisher Art Memorial's focus groups with different immigrant and ethnic populations described earlier (see page 17).

for more on focus group facilities.) Candidates can be screened for specific criteria—for example, *demographics* such as age or gender, *attitudes* such as inclinations toward particular art forms, or *behaviors* such as attendance history—to produce a group whose members fit a particular profile. (If your audience-building initiative targets current or lapsed visitors, you can use your own database or mailing list to identify candidates. The focus group facility or a professional recruiter can call or e-mail potential participants and screen them for eligibility.)

Once you've defined your criteria, they are embedded in an interview protocol called a screener that a recruiter will use to determine a candidate's eligibility. If a person qualifies, he or she is invited to participate in a focus group at a preset date and time. They're typically offered compensation in the form of cash or an item with monetary value, such as a restaurant gift certificate.

As a general rule, it's a good idea to over-recruit by about 20 percent because not everyone who agrees to participate may show up. So, if you want a focus group with 8 participants, recruit 10. If more than 8 come, you have two choices—include them all or thank the extra participants by awarding their incentive and telling them they're free to leave. This should be done discreetly and out of earshot of participants who are asked to stay. (This is quite commonplace and is typically managed by focus group facility hosts.)

4. Consider Group Dynamics

On average, a focus group has eight participants. There can be as few as six (or on rare occasions even fewer) if researchers want to explore certain topics more deeply or if the group is highly involved in the topic and will likely have a lot to say. Sometimes, a focus group can have 10 or more participants if researchers want to hear a greater variety of opinions (but in less depth).

Regardless of the group size, researchers typically select participants with similar backgrounds and experiences. There are a few reasons why. For one, it makes the discussion flow more easily. Just as people tend to socialize with people like themselves, conversations tend to flow better in groups where people have things in common. Individuals who find themselves with people they think aren't like them may self-censor in the interest of keeping the

conversation cordial or avoiding embarrassment. Such inhibition can compromise the ability of the research to deliver information and insights.

Participants who share common ground will also have similar vantage points, and the group discussion can illuminate how that impacts their attitudes about arts participation. A new parent has different demands on his or her time than a recent college graduate or a retiree does, for example. Having separate discussions with individuals grouped by life stage allows those differences, if they exist, to emerge. Moreover, because they are in the company of people with life circumstances similar to their own, the conversation will explore those differences at a deep level as participants share with *each other*. They'll react to each other, build on each other's comments, point out the nuances of their different situations, and likely raise questions that the research team hadn't considered.

Finally, if certain topics pertain only to a portion of your target audience, consider having a separate discussion with that group. For example, arts organizations that have activities for children as well as adults often find it useful to have a separate focus group made up of parents so they can spend some time talking about programs for children and families.

Focus groups work best when they're homogenous and participants feel comfortable with each other, but sometimes a target audience itself is diverse, such as one that includes a wide age range. When that happens, researchers

TIP ▶ It's usually best not to mix visitors and nonvisitors in a focus group. People who've never visited an arts organization will have opinions based on impressions, not experience. They're likely to think about the organization and its art differently than regular patrons do. If you want feedback from both, talk to them separately.

typically conduct separate groups to capture multiple perspectives. Doing so requires thinking about the audience in terms of segments, such as gender, race, age, and social class. Those aren't the only options, however. A museum

might want to interview separate groups of members and nonmembers, for instance, or current patrons and prospects. This does not mean that you need to run separate focus groups for every possible subgroup, but participants will need some common basis for sharing. How do you know if you should do separate groups? These questions can serve as a litmus test:

- Could everyone in the target audience relate to each other in conversation? You'll need to use your instinct to answer this, which depends in part on the conversation topics.
- Could members of the target audience approach the conversation topics in fundamentally different ways because of previous knowledge or experience, life stage, or some other factor?
- Are there topics that may concern only a portion of your target audience?

Sociologist David Morgan suggests an even more straightforward criterion:[7] "The group composition should ensure that the participants in each group both have something to say about the topic and feel comfortable saying it to each other."

5. Do Three Focus Groups—At a Minimum

Focus groups can be swayed by an influential participant, a recent event in the news, or other circumstances. That's the potential downside of research that centers on individual experiences. If you only do two focus groups with similar types of people and cover the same topics, you may get starkly different opinions. Conducting three or more groups lets you compare and contrast opinions and will give you a better sense of how widely shared certain perspectives are.

If your target audience is diverse, you'll want to segment it and run more focus groups to capture that diversity. Ideally, you should do at least three groups per segment if you believe that each segment will have vastly different perspectives. If you don't expect opinions to vary that much and are mainly doing separate groups to create a comfortable dynamic among like-minded individuals, it isn't necessary to conduct three per segment.

7. David Morgan, *Focus Groups as Qualitative Research* (Thousand Oaks, CA: Sage Publications, 1977), 36.

Of course, your budget may not let you cover all the segments you would like to. In that case, it's best to focus on those that are most important to your organization or that you know the least about. Doing fewer than three focus groups in all—or fewer than three per segment when the segments differ greatly from each other—is not advised. You run the risk of drawing conclusions based on the responses of one or two groups that may not represent widely held opinions. Don't do it.

6. Analyze the Data

In practice, the analysis begins in real time as research team members observe the focus groups and informally share their first impressions with each other and the moderator. Team members usually find it rewarding to convene after a session and compare notes about what they saw or heard while it's still fresh in their minds. It can spark new topics or questions to explore if more focus groups are still to come.

The analysis centers on identifying several broad themes heard throughout the conversations and using the proceedings to relay a layered portrait of participants' attitudes and behaviors as well as any motivations or perceptions that underlie them. The moderator takes the lead in writing a formal report that summarizes the findings, highlights the differences between audience segments, and recommends next steps based on what was learned. Very often, the report will include actual quotes from participants. Some moderators work directly from audio recordings of the focus groups to capture the emotions and intonations of participants, while others prefer to use a transcript. Most focus group facilities provide free audio recordings, and also offer video recording for an extra fee, which can be useful if some members of the research team are unable to attend (although there is really no substitute for seeing focus groups live).

Focus Group Budgets and Timelines

Qualitative research can intimidate organizations that have never done it, largely because it's expensive. Even a small focus group project with three groups can cost $15,000 to $20,000 or more. Some of the factors driving that expense are:

- Consultant fees for developing the discussion guide, moderating the groups, and writing the report
- Rental of the focus group facility
- Recruitment of participants (done by a specialized firm or focus group facility)
- Cash or gifts provided to participants in exchange for their time (also called the incentive)

Focus group research begins several weeks before the actual discussions take place. Respondents have to be recruited, a facility must be secured, and conversation topics and interview questions need to be finalized. Table 5 presents a typical timeline for a small focus group project.

Table 5. Timeline for a Typical Focus Group Research Project

Task	Timing
Determine criteria for focus group participants and develop screening interview	Week 1
Develop focus group discussion guide and recruit participants	Weeks 2–3
Conduct focus groups	2 days during Week 4
Analyze data	Weeks 4–6
Report on results	End of Week 6

CREATING EFFECTIVE PROMOTIONAL MATERIALS

Introduction Arts organizations often find that marketing to attract a new audience requires an approach that's different from what works with their current visitors. They might need to place advertising in different newspapers or on different websites, ones that the target audience prefers. It might mean rethinking the text and photos in a brochure to emphasize particular aspects of the organization and its art that would appeal to newcomers and interest them in visiting. It may entail developing promotions that a new visitor would have a hard time passing up.

Often, arts institutions examine their marketing tactics as part of their qualitative research into a new audience's tastes, preferences, and attitudes toward their organization. It is a natural fit; focus groups often bring to light the perceptual (and practical) barriers that keep new people from coming, and the discussion can easily be extended to how well marketing materials dissipate or reinforce those barriers as well as participants' opinions on the image they project of the organization.

The feedback can be difficult to hear. As discussed in Chapter 1, focus groups of teens and young adults unfamiliar with Pacific Northwest Ballet assumed, based on their preconceptions of ballet, that it was a boring and stuffy organization. The company's advertising did not challenge that perception, and may have reinforced it. It can be easy to dismiss such comments as coming from people who "just don't get it"—unless they're the very audience you're trying to attract. PNB acted on the insight and overhauled its promotional materials to more accurately convey the excitement of a live performance and the company's approachability. The revised marketing was one

component in an initiative that saw PNB's ticket sales to teens more than double, and sales to young adults ages 18 to 25 rise 20 percent.

Focus groups can also surface new ways for an organization to talk about its art with an audience that's unfamiliar with it. That doesn't mean watering down the discourse, but rather speaking in a way that is accessible to newcomers and including information that helps them better understand what a visit would be like, why they would enjoy it, and how to plan one (e.g., details that current audiences already know, such as ticket prices or opening hours). The Clay Studio and San Francisco Girls Chorus, whose research is presented in this chapter, learned which aspects of their work interested new target audiences and then showcased those elements in their marketing.

Qualitative research can also expose what is—and isn't—working with your promotional materials as you track and assess an initiative. Minnesota Opera, the third organization featured in this chapter, turned to focus groups midway through its initiative to test its marketing and understand what was holding back its target audience from buying a ticket. The feedback sharpened the company's promotions and contributed to an uptick in sales. (Quantitative research can help fine-tune a marketing plan, too. A visitor survey can provide a read on how people heard about an organization, tracking the impact of marketing dollars and staff time to improve allocation. Read about The Clay Studio's efforts on page 78 in Chapter 3).

After sketching out the case examples, the chapter concludes with several tips on testing promotional materials with focus groups. (More detailed guidelines on conducting focus groups can be found in Chapter 1). What's critical to remember is that focus groups won't come up with a marketing strategy for you. They won't tell you which ads to run or what promotions to offer. At its best, audience research can clarify the challenges inherent in reaching a new audience, expose potential limitations of your current marketing in breaking through to that audience, and pinpoint what kinds of communication will resonate. It's up to staff members to apply those insights to create promotional materials that will help an audience-building initiative succeed, while also remaining consistent with the programming being advertised and respectful of the organization's image.

Case Examples:
USING FOCUS GROUPS TO CREATE
EFFECTIVE PROMOTIONAL MATERIALS

What Gets the Attention of a Busy Audience?
The Clay Studio Finds the Right Words and Images to Entice a New Generation of Visitors

Research ▶ **The Challenge:** The Clay Studio is a 40-year-old institution in the heart of the Old City Arts District of Philadelphia. It offers pottery classes, workshops, studio space for artists, an art gallery, and a ceramics shop. Although the organization had a steady stream of visitors, the staff became concerned in the first decade of the new millennium because they were always greeting the same people at the door—and those people were getting older. They believed that the future of The Clay Studio depended on also attracting new, younger visitors to its programs and events.

The studio did, in fact, welcome some younger people, through its participation in the Old City Arts District's monthly "First Friday" open-house event. The evening brought as many as 2,000 people, many of them under 35, through the gallery and shop. However, few of those passersby ever returned for a class or workshop. The staff was not clear on what would appeal to this younger audience, although they were fascinated by the growing literature and experiences in the field suggesting that 20- and 30-somethings sought experiences that were social and participatory. With that in mind, the studio experimented with several concepts, such as artist talks and gallery receptions.

Nothing clicked with the target group until The Clay Studio introduced social clay workshops in February 2008. The studio had always offered a 10-week pottery class, but it cost $300 and required a substantial time commitment—high hurdles for newcomers who had never worked with clay and weren't sure if they'd enjoy it. The social workshops, meanwhile, were marketed as more relaxed evenings with refreshments and a chance to get your

Figure 3. A Social Workshop at The Clay Studio

hands dirty at a potter's wheel (see Figure 3). Skilled instructors walked participants through a few simple projects and then let people create their first pieces at the wheel. The social clay workshops sold out quickly, and the studio began holding them monthly.

The organization loved seeing so many new faces in the studio and wanted to build on that success. It believed the right marketing could draw more young professionals to its other programs. Still, the studio had never marketed to young people before. It didn't know how they found out about cultural activities, for instance, or whether its brochures would resonate with an audience that was unfamiliar with ceramic arts. **What would be the best way to market The Clay Studio to young people?**

Research Objectives: The Clay Studio had two main objectives for its research:

- Identify how young adults ages 25 to 45 decide which cultural activities to participate in, including where they search for information on options
- Explore how The Clay Studio could present information that would be noticed by young adults and encourage them to take a class or workshop

Method and Research Participants: The studio engaged a research firm to conduct six focus groups with young adults ages 25 to 45 in late 2008, its first foray into qualitative research. (Around the same time, it also did its first-ever visitor survey, which included a few marketing-related questions, such as how respondents had heard about The Clay Studio. Detail on that survey is in Chapter 3.) Each focus group had as many as nine participants, and separate groups were run with adults ages 31 to 45 and adults 30 and younger because the research team believed younger people might use different media channels and choose cultural activities for different reasons. The team further segmented the groups by the degree of their experience with The Clay Studio, from those who had never visited to members and students, as follows:

- Two groups who had not heard of The Clay Studio, one younger (ages 25 to 30) and one older (ages 31 to 45)
- Two groups who had visited The Clay Studio in the past two years, one younger (ages 25 to 30) and one older (ages 31 to 45)
- One group of adults ages 25 to 45 who were the parents of children ages 5 to 12 and had varying amounts of experience with The Clay Studio (some parents had visited, while others had not)
- One group of women ages 25 to 45 who were members and/or students of The Clay Studio (most of the studio's members and students were female)

The recruiters screened all participants to capture only those who were "culturally active," which was defined as having participated in cultural or artistic activities at least six times in the past year in the Center City area of Philadelphia, where The Clay Studio is located. In addition, they had to have participated in two different visual arts activities (e.g., visiting an art museum or going to the movies) at least three times in the past year.

Questions: All of the group discussions followed a similar sequence:

- **Arts and culture in Philadelphia:** Discussion about the local arts scene got the conversation flowing.
- **Attendance at organizations in the visual and performing arts:** Respondents were asked where they went, what kind of experience they looked for (e.g., social, interactive), and why those experiences were appealing. They also discussed their knowledge of and experience with

ceramic art, and what attracted them to or kept them away from it.

- **Choosing among the alternatives:** Participants described how they decided which cultural and artistic activities to do, including whom they consulted and how they weighed factors such as budget, experiences, and the preferences of others in their group. They also discussed lifestyle factors that prevented them from participating, such as inertia, cost, travel, and lack of free time.

- **Information sources:** The groups shared how they heard about cultural activities, including word of mouth, invitations from friends, and announcements or ads on websites, in direct mail materials, in print, and on the radio.

- **Awareness and perceptions of The Clay Studio:** Past visitors gave their opinions on the studio. Participants who had never been there were first asked what they thought The Clay Studio was based on its name alone and, later, based on a description.

- **Feedback on marketing materials:** Participants reviewed two sets of marketing materials to identify the formats, images, language, and information that pulled them in. The first set included brochures from various organizations—a museum incorporating an art school, two local theater companies, a public radio station, and an animal welfare organization. After briefly discussing what they did and didn't like, focus group respondents examined another set of materials that included a brochure from The Clay Studio and brochures from two similar ceramic arts organizations outside of Philadelphia. Participants gave their general impressions of each piece, and then the moderator led a more in-depth discussion about The Clay Studio's brochure that included the following questions:
 - What about The Clay Studio appeals to you as a place to visit, shop, or take classes?
 - How is The Clay Studio different from other galleries you've visited?
 - Does the brochure make you interested in the studio? Do you see it as a place to visit with your friends, your children?
 - What don't you like about the brochure?

- What information is missing that you would want to know?
- What should the brochure say about The Clay Studio to attract first-time visitors?

Aside from this general outline, the moderator tailored each group's discussion based on the backgrounds and experiences of participants. The group of members and students, for instance, talked in depth about their preferred activities at the studio, the benefits of membership, and their impressions of its website and other communications. The parents' group discussed the role of art in their children's lives, their preferred arts activities, and the activities that compete for their free time. Parents who had been to the studio described their involvement and the appeal its programs had for kids.

Results and Actions Taken: The research surfaced several insights that informed how The Clay Studio marketed to young people. "It was fascinating to sit behind the glass and have a complete group of strangers tell you what they think of your printed materials, your studio, and your interactions with them," says Jennifer Martin, vice president of The Clay Studio. Here's what she and the rest of the staff learned:

Promote the experience itself. When focus groups reviewed the selection of brochures, they reacted most positively to those that emphasized what visitors could do at the venue. They were drawn to events and activities that suggested they would have a memorable time. Respondents also liked photos of people enjoying themselves, as opposed to images of clay objects that, in some cases, didn't even look like ceramics and just baffled them. Staff immediately saw marketing opportunities. While the studio offered many ways to experience working with clay, it didn't showcase that aspect in its communications. Its class descriptions focused on what students would learn, rather than the joy of making ceramic art. Ads featured static pictures of clay objects instead of people making them. That approach would get no traction with young people looking for creative and unique activities. Based on the research, the studio incorporated more language and photos into its marketing materials to better promote the experience of working with clay (see, for example, Figure 4 and Colorplates 3 and 4).

The research also led staff to rethink First Friday, the monthly evening open-house event that it hosted with other local galleries. First Friday drew

thousands of young people to the Old City Arts District, but focus groups revealed that their gallery visits left little impression—most couldn't recall the names of places they had stopped by. Even at The Clay Studio, staff saw many visitors leave after a few minutes of passively browsing its shop and gallery. When the research showed the pull that experiences had with young people, staff added several activities to make First Friday more memorable and interactive. They introduced free art-making ("free" was a big selling point to try something new, according to focus groups) and pottery-making contests between the studio's resident artists.

Keep the message simple. The Clay Studio produced a brochure four times a year that included everything but the kitchen sink—descriptions of that season's classes and workshops, instructor biographies, details about special events and exhibits, general news about the organization, board and donor information, and a letter from the president. The information-packed

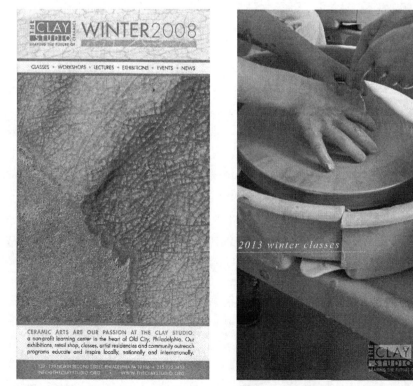

Winter 2008 Winter 2013

Figure 4. Class Brochures for The Clay Studio before and after the Research

brochure quickly lost focus group participants who weren't familiar with the organization. With so much to wade through, they couldn't see what The Clay Studio had for them.

The staff loved the brochure's format, but based on the feedback, they decided to pare it down and include only essential information about classes and workshops, such as descriptions, cost, and registration details. (See sidebar, *Being Open to Change, Even When It's Hard.*) They moved the other course information online, where most students registered. Information about exhibits, lectures, and other programs found a new home on postcards and in e-mails tailored to different audiences.

Make it sound inviting *to them*. At best, terms like "wheel throwing" in the studio's brochure meant nothing to focus group participants who had never visited. At worst, it confused them, or made them think that activities in the studio were for a different crowd. That's not surprising—the organization intended its class brochure for people with some experience with clay, not for newcomers. Still, the feedback underscored that the studio had to promote itself in a more accessible way to new audiences. Consider how it changed its marketing for family workshops. Before the research, the description of one such workshop explained how families would make Easter baskets using "slips," a technical term for liquid clay that novices likely wouldn't know. In contrast, a description for a workshop in 2012 targeting young parents emphasized the "fun" families would have "playing in the mud" as they made planters using the pottery wheel. Staff also took a tongue-in-cheek approach to promoting First Friday events, which drew mostly young newcomers and not the studio's more involved members, by inviting visitors to "get dirty" with clay.

Size matters. Shape and color do, too. When reviewing brochures from a variety of organizations, focus group respondents gravitated toward ones that were printed on high-quality, glossy paper with short headlines, lots of white space, and color photos. They also pointed out that they would be more likely to take home ones that were small and pocketable. The Clay Studio replaced its grayscale 6-by-11-inch brochure with a more colorful, 5½-by-10-inch glossy (Figure 4, right, and Colorplate 4). Staff took a similar approach with other communications, including a summer camp brochure that was redesigned to emphasize the studio's hands-on activities (Figure 5 and Colorplates 5 and 6).

▶ BEING OPEN TO CHANGE, EVEN WHEN IT'S HARD

The Clay Studio staff loved their comprehensive course brochure and its images of beautiful ceramic art. They were proud to show it to their colleagues at other organizations. Problem was, it didn't grab the attention of new audiences. "People in the focus groups would say, 'Why would I pick that up?' 'Why would it make me want to come?' 'I've got to look at something and right away see there's something for me,'" recalls Amy Sarner Williams, then the executive director of The Clay Studio, who had been with the organization since its founding. "And we were all thinking, *We love that and it looks so beautiful.*"

That thinking might have prevailed—and nothing would have changed about the brochure or the studio's marketing. Instead, the staff acted on the focus group feedback, redesigning the brochure and revisiting their assumptions about how to promote the studio. It took some courage. "What's surprising is that we were open to the research results and open to the changes that had to be made, even when they were risky and counter to what we thought we knew," says current president Chris Taylor.

Because of the research, staff members started to look at their marketing and programs through the eyes of their audience, including young newcomers. They knew changes were essential to guarantee the future of the organization, and at times, that meant emphasizing some things and downplaying others that weren't relevant to new people. "We had this tagline, 'Shaping the future of ceramics,' which was great—for us. Not so much for the audience," says Williams. "That was a real eye-opener." The tagline came off much of their marketing to new audiences.

The staff's willingness to embrace the research amplified its value and ultimately, helped The Clay Studio draw new visitors in numbers it had not seen and could not have even imagined. Its enrollment tripled during the four-year initiative, when it revamped its marketing strategy and introduced programs to attract more young people, including five-week classes and weekend workshops. Revenue more than doubled. What's more, enrollment in its traditional 10-week classes also grew.

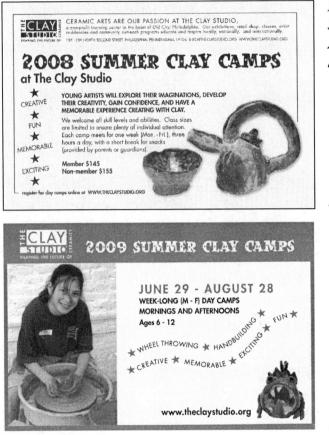

Figure 5. The Clay Studio's Summer Camp Announcements before and after the Research

Summer 2008

Summer 2009

Online marketing is a must. The focus groups confirmed that websites and online listings were the go-to sources for young people looking for information about cultural activities. (The studio's visitor survey reflected the same trend. See page 78 to read more about it.) The Clay Studio had already started marketing online, but it ramped up those efforts based on the research. It worked on search engine optimization to ensure that its website ranked high in search results, developed an e-mail marketing plan, and sharpened its social media strategy to build a greater sense of community with visitors.

Cost: Approximately $35,000 to $40,000 for six focus groups

How Can We Combat Stereotypes about Us?
San Francisco Girls Chorus Finds the Words and Images to Convey Its Artistic Excellence to a Discerning Audience

Research **The Challenge:** The San Francisco Girls Chorus (SFGC) is a choral music group with an international reputation that has won five classical music Grammy awards. SFGC staff were thrilled that so many friends and families of chorus members attended concerts to support the organization, but they were stumped by the absence of another key audience—classical music enthusiasts. To address this challenge, they first had to answer one important question: **Why weren't patrons of other classical music venues in the Bay Area attending SFGC concerts?**

Research Objective: SFGC wanted to understand what classical music enthusiasts thought of girls choral music and its organization, and how that compared to other classical music performances they currently attended. It also wanted to know what messages its marketing sent. SFGC was not looking to change itself or the music it performed. Instead, it hoped to use these insights to identify ways to present itself that better reflected its reputation and matched the kind of experience that discerning classical music patrons seek.

Method and Research Participants: SFGC worked with research partner Martin & Stowe to conduct three focus groups with classical music patrons recruited from lists provided by the San Francisco Opera, San Francisco Symphony, Philharmonia Baroque Orchestra, and San Francisco Performances, a classical music and dance organization. All of the participants were good prospects; they lived locally and had attended at least two classical music performances in the Bay Area within the past year, but had never been to an SFGC concert. They also met several other qualifications: age (25 to 65), income ($75,000 or more for singles, $100,000 or more for married couples or domestic partners), education (college degree), and openness to attending a choral music performance. While age varied considerably, SFGC did not segment the groups because the participants were similar on other demographic measures and shared a passion for classical music.

Questions: SFGC expanded upon the typical research questions used to explore perceptual barriers with new audiences—What do they know about us? What do they think about our art form?—to find out what classical music patrons thought about choral music and the SFGC's concerts in particular. Each focus group covered the following topics:

- Awareness and perceptions of choral music, choral groups in general, and experience with specific choral organizations as a spectator or performer

- Awareness and perceptions of SFGC based on actual knowledge or associations with its name and genre

- Expectations of attending an SFGC concert. To draw this out, the moderator led participants through a "guided visualization" exercise that asked them to imagine being invited to and attending an SFGC performance. They were asked to describe the venue and performance, how the event would unfold, and how they would feel afterward. They were also asked to compare the experience to those they'd had at other classical music performances and what questions they would have about the Chorus. Through this exercise, the researchers hoped to unearth preconceptions and hidden assumptions about choral music and SFGC itself.

- Information sources about cultural events and their expectations for a classical performance

- SFGC's print and online marketing. The organization wondered whether its marketing resonated with the tastes and preferences of classical music patrons, so it asked participants to review the homepage of its website and the most recent season brochure. One group was also shown a printed brochure from an earlier season. Participants discussed the overall appeal of each marketing piece, as well as the messages conveyed by the images and text. Follow-up questions delved into how well those messages aligned with what participants looked for in cultural activities.

- Brand positioning. The focus groups reviewed 10 "positioning statements" highlighting different aspects of the Chorus that it could use in its communications. All of them described the organization to

Table 6. San Francisco Girls Chorus Positioning Statements

THE SAN FRANCISCO GIRLS CHORUS ...

... delivers to music lovers a rich exploration of the choral repertoire, from classically based choral works to folk songs to contemporary fare.

... is an innovator in the creation and performance of new music to showcase the young female voice.

... delights music lovers with fresh interpretations of musical masterworks.

... performs with accomplished guest artists to deliver rich and satisfying performances that feature solo and choral voices.

... is the San Francisco Bay Area's premier young female choral ensemble.

... provides classical music lovers with a deep and rich exploration of the classical vocal repertoire.

... is recognized for its musical excellence through its national and international tours, its participation in world-class competitions, and its expanding discography.

... excites music lovers with its spirited performances of choral music and professionally choreographed movements.

... engages its audiences with the rare combination of youthful voices performing at a near professional level.

... inspires audiences with its uplifting performances.

Courtesy of San Francisco Girls Chorus and Martin & Stowe, Inc.

some extent, such as what it represents in the music world and the unique experience to be had at its concerts (see Table 6). Participants wrote down how each statement made them feel about SFGC, thinking through their own reactions before sharing them with the group.

Results: Overall, classical music patrons knew very little about girls choral music and had low expectations for girls choruses. Indeed, they based their perceptions on the SFGC name alone—without having seen the chorus, they found it hard to picture a professional organization. The visualization exercise proved particularly telling. Focus group participants imagined a group of amateur female singers standing stiffly on stage, with no movement, solos, or anything dramatic to break the monotony. They expected an array of short, simple songs that would be nothing like the challenging classical music pieces that they enjoyed. They assumed one concert looked much like the next.

To be sure, these negative stereotypes about girls choral music and SFGC were difficult for staff to hear. They recognized, however, that these were only perceptions and not based on actual experience with the art form or the organization. They also knew that the only way to effectively dismantle stereotypes was to figure out what they were and, to the extent possible, what could effectively challenge them.

Those perceptions were reflected in focus group participants' questions about the Chorus. The discussion exposed some important knowledge gaps, particularly about performance quality. Some participants asked if SFGC was just an "after-school" activity or something more accomplished. In the absence of any information, they assumed it would be amateurish. Additional questions about the performance revealed what was important to this audience—and what SFGC would need to do to build a following with them:

- Does it offer a high-quality musical experience?
- What would be performed?
- Would it be visually and musically engaging?
- What is compelling or unique about girls' voices? (Few knew that girls choral music is a unique genre.)
- Where does it perform? (Focus groups preferred certain venues and saw others as strictly for amateurs.)

SFGC's marketing unwittingly buttressed some stereotypes, or at least didn't challenge them. When asked to describe a photo on the organization's website that showed the Chorus in their uniforms by the Golden Gate Bridge, focus groups said it looked more like girls on a "field trip" or a "Girl Scout outing" than an accomplished ensemble (see Figure 6, top and Colorplate 7, top). On the other hand, they reacted favorably to images of smaller groups or individual performers showing more emotion (see Figure 6, bottom and Colorplate 7, bottom).

Regarding the positioning statements, researchers paid particular attention to what phrases and words resonated most with the focus groups. Phrases such as "spirited performances" and "engages its audiences" challenged perceptions

Figure 6. SFGC Images Presented to Focus Group Respondents

that SFGC concerts were dull. "To showcase the female voice" implied solos and suggested something more intimate. It conveyed something special about the young female voice that classical music patrons had not considered before.

Acting on the Results: SFGC distilled four key steps it needed to take to attract classical music patrons:

1. Maintain professional, high-quality artistic standards with substantial and challenging programming
2. Offer a visually engaging experience (e.g., by incorporating movement and guest artists)
3. Hold performances at respected venues where classical audiences feel at home
4. Build a clear, consistent, and compelling brand identity that communicates sophistication and artistic excellence

In fact, SFGC was already halfway there. It was committed to high artistic standards with a challenging repertoire. It presented concerts that were already visually interesting, with lots of movement and guest artists. Problem was, it was doing so in obscurity. Its concerts weren't always held in venues that classical music patrons deemed to be professional, and the front-of-house experience wasn't as smooth as at other classical music performances. Based on the research, the staff moved concerts to recognized classical music venues, outsourced its box-office functions, and created a more polished front of house. SFGC also overhauled its website and brochures to convey a more sophisticated image. Throughout these significant changes, the Chorus's repertoire remained the same, and it continued to commission original work. As a result of its efforts, classical music patrons grew from 18 percent to 28 percent of its audience in one year's time. How did it know? A simple but effective audience survey that tracked the progress of its initiative (read more about that research in Chapter 3, on page 67).

Cost: $18,000 for three focus groups, including professional recruiting, moderating, and report writing

Research Materials: Please see Appendix 1 for SFGC's focus group screener used to recruit participants and its focus group discussion guide.

How Can We Get More First Timers to Return?
Focus Groups Identify a Big Hurdle for Newcomers to Minnesota Opera

Research ▶ **The Challenge:** Perhaps no art form has a harder time cultivating new audiences than opera. People who've never been to the opera often believe it is elitist, and certainly not a place they'd like to spend a Saturday night. Minnesota Opera set out to dispel those preconceived notions among women ages 35 to 60 through an innovative partnership with local talk-radio host Ian Punnett. Punnett is an opera fan although his show focused on gossip and pop culture. He told his female listeners about upcoming performances at the Minnesota Opera and explained why they would like them. Listeners could call in to get free tickets—and many did, at times overwhelming the organization's box office. Staff heard anecdotally that these new audience members enjoyed their first time at the opera; in fact, many took advantage of subsequent giveaways to return on another free ticket. However, getting them to *buy* a ticket was an uphill battle, particularly early on. **How could Minnesota Opera get more comp recipients to buy a ticket? If they enjoyed the experience, what was holding them back?**

Research Objectives: Minnesota Opera wanted to know what comp recipients thought of their experience at the opera, as well the organization's marketing efforts, so it could convert more of them into paying customers. Its specific objectives included:

- Understanding what motivated a comp recipient to attend the opera, including key rational and emotional drivers
- Identifying the most and least rewarding aspects of their visit to the opera
- Determining how their experience stimulated or diminished their interest in attending future performances
- Understanding how well its marketing materials appealed to new audience members

Method and Research Participants: Minnesota Opera worked with Martin & Stowe, a professional research firm, to recruit and conduct four focus

groups with comp ticket recipients. Specifically, they assembled two groups whose members had never attended live opera before the ticket giveaway, and two groups who had, in order to get a mix of opinions. The focus groups ran one and a half to two hours, and attendees received a cash incentive for participating.

Questions: A professional moderator began with a warm-up exercise in which participants briefly introduced themselves and talked about the kind of entertainment they enjoyed. Then the discussion followed a structured flow and covered the following topics:

- Exposure to and feelings about opera prior to their receipt of comp tickets
- How they heard about the comp tickets, their initial reaction to the offer, and what compelled them to participate
- Their experience at the Minnesota Opera and how it affected their feelings about opera overall and Minnesota Opera in particular
- Whether they had purchased or planned to purchase tickets to the Minnesota Opera and under what conditions
- Reaction to marketing materials and ideas, including two television commercials, a brochure, and a prototype of a postcard

Results: Minnesota Opera paid the closest attention to comments that were shared by multiple participants. Among other things, it learned that Ian Punnett's enthusiasm about and knowledge of opera successfully addressed some obstacles that keep people away from the art form. Focus group participants reported feeling led to the opera by Punnett's having shared his enthusiasm on his radio show over a long arc of time. For them, Punnett was a "regular guy." If he liked opera, they figured they might, too. He assuaged any hesitation they had about calling for a comp ticket because he told them why they would enjoy a particular opera, often referring to its dramatic story line or the grandeur of the spectacle. He assured them that there were captions projected above the stage, so they could follow the opera even if it wasn't sung in English, and that he would welcome them at Opera Insights, a pre-performance discussion where they could learn more about the performance. Once they got to the opera, they enjoyed their experience. They did not find

it intimidating—a fact that surprised many members of the opera staff—and were amenable to returning.

Then why weren't they paying to do so? The focus groups revealed a key barrier to buying a ticket that had little connection to price, the oft-held perception of opera as elitist, or satisfaction with the performance quality. It turned out that actually choosing an opera was an obstacle. Newcomers simply weren't familiar enough with opera to know which one they might like. That insight surfaced when participants reviewed a postcard announcing the opera's upcoming productions and ticket prices. The marketing piece puzzled them. They didn't recognize any of the opera titles, composers, or artists, and there were no clues to help them figure out which opera they might like. Unlike with the ticket giveaway, Punnett wasn't there to guide them.

A glossy, four-color brochure promoting Minnesota Opera's season elicited similar feedback. While the photographs and detailed plot descriptions provided some guidance, the focus group participants still didn't feel confident enough to make a decision and risk money on something they might not like, even if they enjoyed their initial experience. Their comments were along the lines of, "It all sounds so good, but I don't know how to pick," says Minnesota Opera Marketing and Communications Director Lani Willis. "We thought we were doing such a good job designing these beautiful brochures with emotional photographs and engaging copy. That was all true, but people couldn't make a decision." The result was inertia.

Acting on the Results: The focus groups gave Minnesota Opera a clearer picture of why more comp recipients weren't buying tickets and helped shape its marketing efforts. Rather than focus on elements of the opera experience itself, the staff realized that they had to help people choose what to see or otherwise give them a solid reason to make a decision. They tried several experiments with limited success, including an online quiz and call-outs in promotional brochures to highlight operas that were good for a "newbie." One of the company's most fruitful strategies has been to offer a 50 percent discount on first-time subscriptions immediately following a performance but only available that evening, removing the possibility for postponing the decision. The "impulse buy" promotion regularly sells 100 new subscriptions at *each performance* when it's offered.

The company has also tried simplifying promotions, or in the words of Marketing Manager Katherine Castile, "telling people what to do." Take its new approach to subscription sales. With seven seating levels and two pricing structures depending on performance day, as well as the option to subscribe to three, four, or five operas, the possible combinations could quickly get unwieldy for someone who's not familiar with opera or the opera house, again leading to inertia. For a recent promotion, the marketing team limited the number of possibilities and ran a "3 for $75" offer in the fall arts preview guide distributed by local weekly newspaper, *Minneapolis City Pages*. The promotion drew 94 new subscriptions. Similar offers have also yielded a high response rate.

Of course, no one in the focus groups suggested such a promotion or said, "You know what would work? An impulse buy." That was the work of Willis and her staff, who listened carefully to the focus groups, gained a deeper understanding of their decision-making process, and used those insights to develop promotions that would move newcomers past their inertia.

Cost: $25,000 for four focus groups. This included the cost to recruit participants, development of interview guides and screening questionnaires, facility rental, incentives, and professional services for moderating the groups, analyzing the data, and reporting the findings.

Research Materials: Please see Appendix 1 for Minnesota Opera's focus group screener and discussion guide.

Colorplate1: Advertising for Pacific Northwest Ballet before Focus Groups

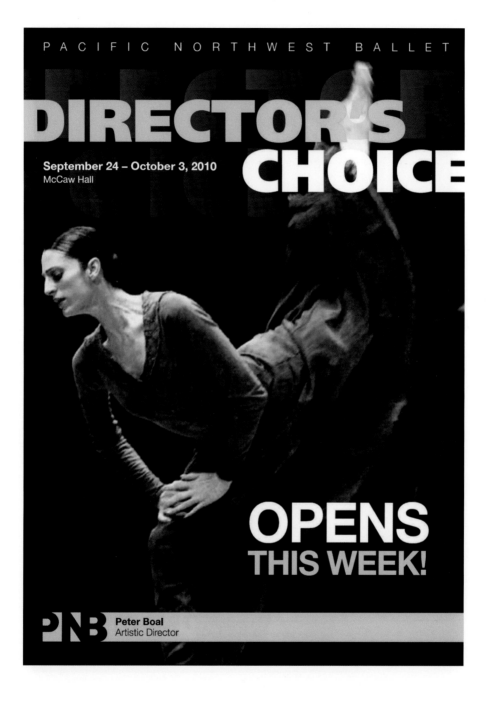

Colorplate 2: Advertising for Pacific Northwest Ballet after Focus Groups

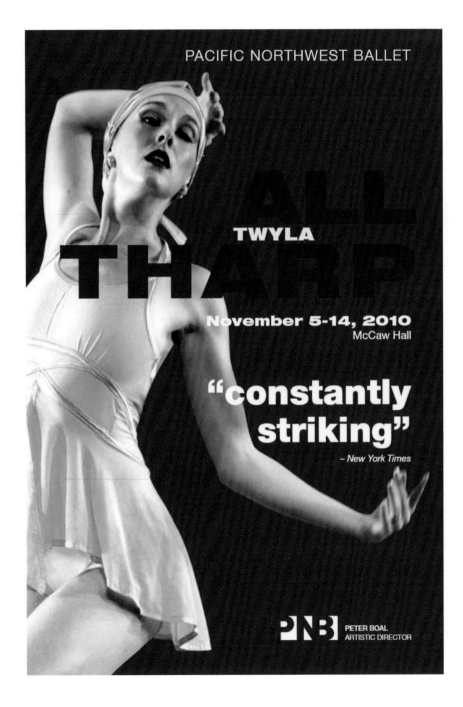

Colorplate 3. Class Brochure for The Clay Studio, Winter 2008

THE CLAY STUDIO CERAMICS
SHAPING THE FUTURE OF

WINTER 2008

CLASSES · WORKSHOPS · LECTURES · EXHIBITIONS · EVENTS · NEWS

CERAMIC ARTS ARE OUR PASSION AT THE CLAY STUDIO, a non-profit learning center in the heart of Old City, Philadelphia. Our exhibitions, retail shop, classes, artist residencies and community outreach programs educate and inspire locally, nationally and internationally.

137 - 139 NORTH SECOND STREET, PHILADELPHIA PA 19106 · 215.925.3453
INFO@THECLAYSTUDIO.ORG · WWW.THECLAYSTUDIO.ORG

Colorplate 4. Class Brochure for The Clay Studio, Winter 2013

Colorplate 5: The Clay Studio's Summer Camp Announcement before the Research

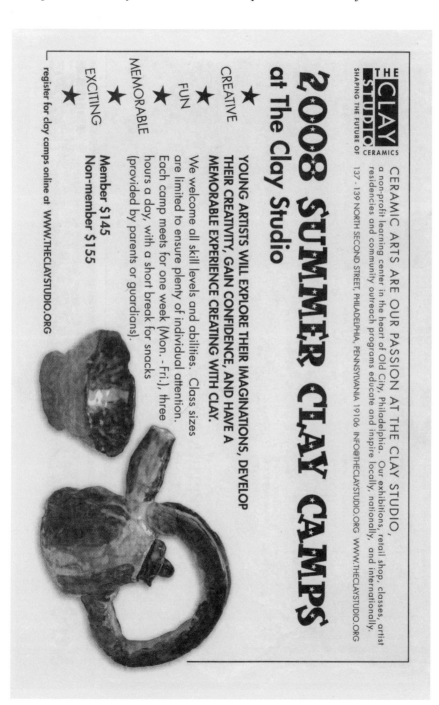

THE CLAY STUDIO
SHAPING THE FUTURE OF CERAMICS

CERAMIC ARTS ARE OUR PASSION AT THE CLAY STUDIO, a non-profit learning center in the heart of Old City, Philadelphia. Our exhibitions, retail shop, classes, artist residencies and community outreach programs educate and inspire locally, nationally, and internationally.

137 - 139 NORTH SECOND STREET, PHILADELPHIA, PENNSYLVANIA 19106 INFO@THECLAYSTUDIO.ORG WWW.THECLAYSTUDIO.ORG

2008 SUMMER CLAY CAMPS
at The Clay Studio

★ CREATIVE
★ FUN
★ MEMORABLE
★ EXCITING

YOUNG ARTISTS WILL EXPLORE THEIR IMAGINATIONS, DEVELOP THEIR CREATIVITY, GAIN CONFIDENCE, AND HAVE A MEMORABLE EXPERIENCE CREATING WITH CLAY.

We welcome all skill levels and abilities. Class sizes are limited to ensure plenty of individual attention. Each camp meets for one week (Mon. - Fri.), three hours a day, with a short break for snacks (provided by parents or guardians).

Member $145
Non-member $155

register for clay camps online at WWW.THECLAYSTUDIO.ORG

Colorplate 6. The Clay Studio's Summer Camp Announcement after the Research

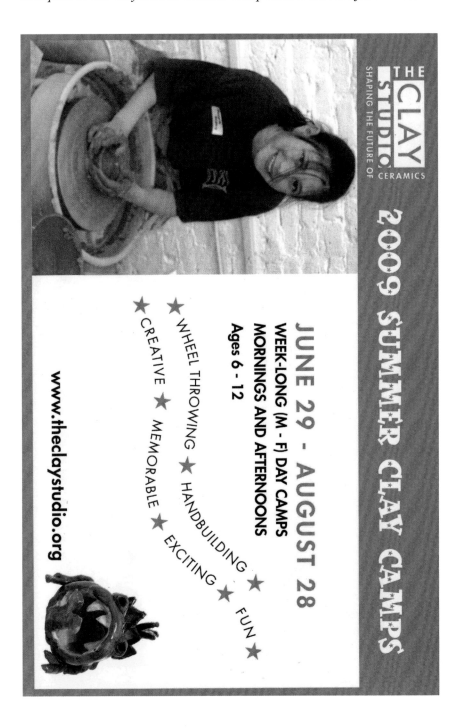

Colorplate 7. SFGC Images Presented to Focus Group Respondents

Colorplate 8. SFGC Audience Survey

Answer a few short questions and have the chance to win an iPod Nano*

2008-2009 SEASON

San Francisco Girls Chorus

SUSAN McMANE, ARTISTIC DIRECTOR

30 Years of Extraordinary Music

Name _____

Address _____

e-mail _____ phone _____

Please complete the back of this card

contact information must be provided to notify you if you win.

San Francisco Girls Chorus

Please answer a few short questions. The information you provide will help us obtain funding to continue our work. And, it will also qualify you to enter a drawing to **win an iPod Nano.**

1. Is this the first time you have attended a performance of the San Francisco Girls Chorus?
❑ Yes ❑ No

2. Have you attended any of the following types of performances in the past six months–opera, symphony orchestra, choral music, other classical music including chamber music, recitals etc.?
❑ Yes ❑ No

3a. Are there children under 12 in your household?
❑ Yes ❑ No

3b. [If you have children under 12] Are they with you here at this performance?
❑ Yes ❑ No

4. How did you learn about tonight's performance?
❑ newspaper ❑ radio ❑ television ❑ brochure/flier
❑ by mail ❑ Website ❑ Word of mouth

5. Are you a friend or relative of someone in the chorus?
❑ Yes ❑ No

6. What is your age? _____ Sex: ❑ Female ❑ Male

Please complete the other side of this card.
Thank you.

TRACKING AND ASSESSING RESULTS

Introduction Audience-building by its very nature involves risk because it's difficult to know what will and won't work with a new audience. And when organizations try completely new things to attract and/or engage audiences, there's even greater uncertainty. Research to track and assess outcomes—even if it's simple—will not only tell you if your initiative is on track, but also help you and your audience get the most out of your efforts. It can provide an accurate read on who is visiting and the experience they're having with your organization. If the initiative is going well, research can even suggest ways to build on it. If it isn't going as you had hoped, research can help diagnose the problem and find solutions.

Research to track and assess outcomes can be quantitative, qualitative, or a combination of both, depending on the type of information you want to know. Quantitative research, such as an audience survey, is the best choice when you want to know *how well* your initiative is working. It can provide objective counts of *who* is visiting, *what* they are doing, and *how much* they enjoy their experience, among other things. Qualitative research can tell you *why* things are working the way they are by helping you understand visitors' subjective experiences. It can also surface ideas for potential improvements. The Isabella Stewart Gardner Museum, for instance, conducted qualitative interviews with new visitors to understand how they experienced its programming and to identify ways to deepen engagement with them (see Appendix 2 for a full description of its research).

An audience survey, covered extensively in this guide, is one of the most reliable means of measuring program effectiveness. It quantifies, or counts, your patrons according to certain criteria, such as demographic characteristics,

attitudes, or behaviors. Surveys also can give you diagnostic information to help you fine-tune your organization's programs.

Of course, that's if you ask the right questions on the survey *and* make sure they're easy to understand so respondents are able to provide the diagnostic information you're seeking. A well-constructed survey offers another benefit too—the results are straightforward to analyze. It's also critical to be mindful that not everyone in your target audience will complete your survey—it's just not practical. However, the subset of people who do take it (called a *sample*) should represent the whole audience whose experience you want to understand.

The following examples show how three organizations—all with minimal budgets—used surveys to effectively measure the success of their audience-building initiatives. The first used a brief but highly effective survey to see if it was attracting a new target audience, while the other two delved more deeply into their visitors' experiences. Step-by-step guidelines on how to design and conduct a visitor survey follow the examples.

Case Examples:
USING SURVEYS TO TRACK AND ASSESS RESULTS

Who's in the Audience?
Survey Confirms That the San Francisco Girls Chorus Is Drawing a New Kind of Concertgoer

Research ▶ **The Challenge:** As described in Chapter 2, the San Francisco Girls Chorus is an award-winning choral music group with an international reputation. Problem was, not enough classical music aficionados in the Bay Area knew it existed. Its performances mainly drew the friends and families of chorus members, not music enthusiasts who the organization believed would enjoy its concerts. Focus groups in April 2008 with patrons of other classical music organizations in the Bay Area confirmed the hunch of senior staff: Classical music patrons not only were generally unaware of girls choral music and the SFGC in particular, they also associated the phrase "girls chorus" with young amateurs singing pop music or children's songs (read more about the focus group research in Chapter 2). Photos in SFGC's marketing materials inadvertently fed into these stereotypes. Focus groups said the chorus looked more like an after-school glee club than a world-class performing ensemble. Guided by these findings, SFGC revamped its marketing materials and some performance elements to project an identity that accurately reflected its sophisticated repertoire and artistic prowess. It also procured a list of known classical music patrons and mailed them its redesigned season brochure. **But would these steps be enough to bring classical music lovers to SFGC concerts?**

Research Objective, Method, and Research Participants: SFGC wanted to know if its rebranding efforts were drawing classical music enthusiasts to its regular season concerts. To do so, it took "before" and "after" measurements of concert attendees. It first surveyed its audience *before* the launch of the rebranding campaign, at its spring concerts during the 2007–2008 season

(the SFGC season begins in the fall and comprises two fall concerts and two spring concerts). This baseline survey counted how many audience members belonged to two mutually exclusive groups:

- Friends and family members of chorus members
- Classical music patrons who were neither friends nor family of chorus members *and* who had attended another classical music performance in the last six months

The survey also asked respondents if they were first-time attendees, who could fall into either group. Having this baseline data let SFGC use follow-up surveys to track whether it was attracting more classical music lovers.

Staff placed the baseline survey on all seats before the doors opened and collected them both before the performance and during intermission. Only 65 people out of 699 concert attendees completed it—a low response rate of about 9 percent—likely because it ran a full page and may have appeared too tedious to complete. Such a low response rate can threaten a survey's validity (see "Quality Control: Monitor Response Rate," on page 101). The organization recognized this rate was unacceptable, and to boost participation moving forward, shortened the survey to fit on a postcard that could be easily distributed in concert programs and collected (see Figure 7 and Colorplate 8). It also used larger fonts and a clear layout to make the survey seem less intimidating. All audience members received a survey, and as an incentive, SFGC entered respondents into a drawing for an iPod Nano.

Questions: The postcard format forced SFGC to focus its questions on strategically useful information. It settled on asking about the following:

- Whether it was the audience member's first visit to an SFGC concert
- Whether the audience member had recently attended other classical music events
- Whether the audience member had children under age 12 at home (potentially useful information to help SFGC in a parallel effort to attract parents to its concerts)
- How the audience member had learned about SFGC
- Whether the audience member was a friend or relative of a Chorus member
- The respondent's age and gender

Figure 7. SFGC Audience Survey Postcard

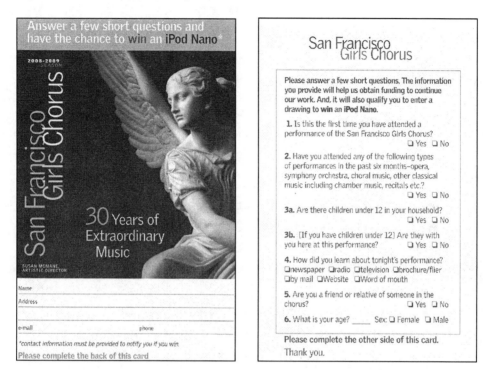

Front Back

While it would have been interesting to ask other questions, such as whether people enjoyed the performance or if they would likely return, doing so would have lengthened the survey and thus probably lowered the response rate.

SFGC also asked respondents for their names and contact information in order to notify them if they won the iPod (and to add them to its mailing list). Collecting personal information can sometimes backfire if a survey goes beyond demographic questions and solicits opinions about a performance or exhibit. People may not answer candidly—or take the survey at all—if they believe the information can be traced back to them.

The postcard format worked better, netting an average response rate of 36 percent—much higher than the baseline questionnaire. A total of 481 attendees took the survey in the 2008–2009 season and 367 in the 2009–2010 season.

Results: The baseline survey before the rebranding found that classical music patrons made up 18 percent of SFGC's audience. Only 5 percent were both classical music enthusiasts and first-time attendees—indicating, as SFGC suspected, that it wasn't drawing many new classical music patrons.

Once the marketing campaign got underway, SFGC distributed the postcard survey at all of its regular season concerts during the 2008–2009 and 2009–2010 seasons. The organization also surveyed the audience at its annual holiday concerts, which, as it turned out, attracted more classical music patrons than its fall and spring performances did. Given that the holiday shows had broader appeal and were marketed differently than its regular concerts, SFGC decided to exclude those surveys from its final results. That was a smart move. When tracking change, it's important to make "apples to apples" comparisons. SFGC's baseline survey was of its regular-season audience. If its follow-up surveys had included holiday-show attendees, the results would not have been comparable.

As shown in Figure 8, SFGC saw a statistically significant increase in the percentage of classical music patrons after it rebranded, jumping from 18 percent to 28 percent in the first year. The number of first-time attendees who were classical music enthusiasts nearly tripled, from 5 percent to 13 percent. That percentage stayed fairly steady in the 2009–2010 season, while the

Figure 8. Percentage of Classical Music Patrons in the Audience

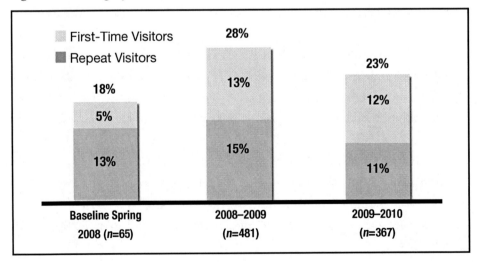

overall percentage of classical music patrons dipped to 23 percent. (The differences in the response rate between the baseline and follow-up surveys make the comparison much less than ideal. It's important to perfect the methodology before taking critical measurements. However, it would be difficult to conclude that the results were entirely due to response-rate differences given both the relatively large number of people who completed the follow-up surveys and the degree of change that was found.)

Although pleased that it attracted more classical music patrons, SFGC was somewhat disappointed to find that it didn't build a base of repeat visitors over the course of the two seasons. Instead, repeat visits by classical music enthusiasts stayed flat from the baseline.

Acting on the Results: SFGC conducted its audience surveys to find out who was coming to its concerts and whether its rebranding efforts led more classical music patrons to attend. Taken together, the surveys suggest that it had some success in drawing a new audience of classical music lovers, but it didn't retain those newcomers from year to year. Based on this finding, SFGC pursued further audience research to better understand *why* people come to its concerts—and what makes them return.

Cost: $3,000 each season, or a total of $9,000. By keeping the survey simple, SFGC was able to do much of the work itself and keep costs low. Staff members wrote the survey themselves with guidance from a survey professional and added more ushers at concerts to collect completed questionnaires from attendees. For each season, the organization paid $1,500 to print the survey and $1,500 to a market research firm that entered, tabulated, and produced a simple report on the data.

Are Our New Programs Attracting and Engaging New Audiences?
The Isabella Stewart Gardner Museum Uses Visitor Survey Data to Build on Success

Research ▶ **The Challenge:** In 2007, the Isabella Stewart Gardner Museum in Boston launched *Gardner After Hours*, an after-work social event designed to attract young adults (as described in Chapter 1). It was new territory for the museum. While other institutions had shown it was possible to draw young people to a social event after work, getting them to engage with the art was another matter entirely. Often, the art got lost. Gardner staff wanted attendees to enjoy the evening's social aspects as well as the art. To that end, they designed activities, informal talks, and games to stimulate exploration of the collection. Staff had some reservations about the museum's suitability for evening events, particularly social ones, given that its galleries are small. They weren't sure if they could create an evening that people would enjoy, let alone return for.

First, though, the museum had to get them through the front door. The staff created fresh marketing materials as well as undertaking a new media strategy—including ads in alternative weeklies, text messaging, social media, and more—to build buzz about the event.

From its first evening in September 2007, *After Hours* attracted large crowds of more than 500 visitors. **But was it drawing young adults—and were they engaging with the art? What kinds of activities could most effectively draw them into the collection?**

Research Objectives: Museum staff had several evaluation objectives. First, they wanted to know if *After Hours* was attracting newcomers ages 18 to 34. They also wanted to find out what people did at the event. Did they stick close to the bar in the courtyard and chat with friends, or did they peruse the art in the galleries? If they engaged with the collection, what did they enjoy most? Did they enjoy themselves enough to want to come again? Finally, the staff wanted to gauge the effectiveness of its marketing by asking people how they had heard about *After Hours*.

Method and Research Participants: Gardner conducted an exit survey during the first two years of *After Hours*. Volunteers handed out the survey at

7 of the 10 evenings the first year and 6 of the 11 evenings the second year. Staff specifically chose not to do face-to-face interviews because when evaluating other programs in the past, they had received an overwhelming number of positive responses to this method. They suspected that respondents might have felt uncomfortable being completely frank with museum volunteers conducting the interviews.

About two hours after the event began, survey volunteers were stationed in the hallway leading to the exit door to catch people as they were leaving. They also approached visitors in line for coat check. As many as six volunteers were on hand during the peak exit time of 8:30 to 9:15 p.m. They asked visitors if they had two minutes to fill out a survey, offering posters and other small gifts as incentives. To make it easier for respondents to participate, the volunteers had golf pencils and clipboards for writing surfaces. They collected the surveys once they were complete. While the survey followed most guidelines regarding survey administration, it did not establish a protocol for randomly selecting respondents, such as an every *n*th rule (see "Representative Samples: Talk to the Right People" and "Choose Carefully: Selecting Audience Members to Take a Survey," on pages 93 and 100, respectively). This opens the possibility of bias in the sample. Julie Crites, then director of program planning, reports not seeing any evidence of bias, but adds that volunteers could have favored guests who looked more "approachable." When respondents are not randomly selected, it's impossible to know whether a bias exists and, if so, what its impact is.

TIP If you have visitors coming and going at your event, don't wait until it's over to survey them. You'll miss the people who have already left, which could exclude specific groups such as families that had to leave early or visitors who may have left because they weren't enjoying themselves. Conduct the survey throughout the event to capture a wide range of visitors—and opinions.

Questions: Besides collecting demographic data such as age, gender, and ethnicity, the survey asked whether it was the person's first visit to the museum or first time to *After Hours*. It also included a list of the activities available at the event and asked respondents to indicate which ones they did, as well as to circle the one they enjoyed most. Staff modified the list to fit each evening's programming, which changed slightly from month to month. In addition, the museum asked how people had learned about *After Hours* to measure the success of its marketing. Because word-of-mouth is so important with young adults and the staff hoped to build buzz, they also asked if visitors would recommend the event to friends.

Results: The percentage of *After Hours* visitors completing the survey in any given evening ranged from 12 to 23 percent of all attendees in the first year and 5 to 14 percent of all attendees in the second year. This is not the same as the response rate, which is the percentage of surveys completed out of the total number handed out. Gardner didn't track how many surveys it distributed, and as a result, it lost a critical piece of information to help determine how well the sample represented its full audience (see "Quality Control: Monitor Response Rate," on page 101). While a relatively high number of overall visitors took the survey, having the response rate is handy in case you need to figure out if any data points are anomalies.

Figure 9. Example of SurveyMonkey Output

4. How likely would you be to recommend After Hours to a friend?		Response Percent	Response Count
Extremely likely to recommend		71.0%	414
Somewhat likely to recommend		26.6%	155
Neither likely nor unlikely to recommend		1.4%	8
Somewhat unlikely to recommend		0.9%	5
Extremely unlikely to recommend		0.2%	1
		answered question	583
		skipped question	10

Museum staff tabulated the results in-house using SurveyMonkey, an online survey tool that summarized the responses and converted them into easy-to-understand visual reports. A spreadsheet program such as Microsoft Excel would have worked fine, as well.

Table 7 shows the aggregated results, which clearly demonstrate that the museum attracted its target demographic to *After Hours*. Two-thirds of attendees in the first year, and 73 percent in the second, were 18 to 34 years old. The results also confirmed that *After Hours* was much more than a social event. Nine out of ten visitors explored the galleries in the first year, compared to 66 percent who went to the courtyard bar. More than half—54 percent in the first year and 52 percent in the second—said visiting the galleries was the activity they enjoyed most, far exceeding any other element of the evening. Not all of the programming was a success. A self-guided tour seemed to have appeal based on how few copies of the handout were left over in the galleries at the end of the evening. But the survey surfaced an important finding: Compared to the percentage of attendees who did the self-guided tour (16 percent in the first year and 17 percent in the second), few said it was among the things they most enjoyed (2 percent and 4 percent, respectively).

Because it fielded the survey for two consecutive years, the museum could track how well the event attracted repeat visitors, too. In 2007–2008, 12 percent of visitors had attended *After Hours* before, a figure that grew to 25 percent the following year.

Acting on the Results: The survey did three things. First, it confirmed that *After Hours* was attracting the target audience. That meant staying on course for the marketing team, which had developed a unique plan for promoting the event. If fewer than half of the attendees had fallen within the target demographic, the team likely would have revisited its tactics. As it turned out, the survey showed that most people heard about *After Hours* through word of mouth, giving the staff the confidence to cut paid marketing by more than 20 percent in the second year of the initiative. When the event continued to draw large crowds—and the survey again showed word of mouth was fueling it—they slashed their marketing budget again the following year—by more than an additional 50 percent—and attendance continued to grow.

Table 7. Results from After Hours *Exit Surveys*

	2007–2008 (n=593)	2008–2009 (n=394)
Activities		
Visited the galleries	89%	93%
Sketched in the galleries	9%	11%
Participated in a Viewfinder gallery talk [organized conversations around a work]	17%	16%
Visited the special exhibition	N/A	19%
Visited the courtyard bar	66%	69%
Ate at the Gardner café	19%	11%
Attended performance in the Tapestry Room	27%	31%
Took the self-guided tour	16%	17%
Played the gallery game	N/A	23%
Activity enjoyed most		
Visiting the galleries	54%	52%
Sketching in the galleries	7%	6%
Participating in Viewfinder gallery talk	16%	7%
Visiting the special exhibition	N/A	4%
Visiting the courtyard bar	12%	11%
Eating at the Gardner café	5%	3%
Attending performance in the Tapestry Room	15%	19%
Taking the self-guided tour	2%	4%
Playing the gallery game	N/A	13%
Age		
18–34 years old	66%	73%
18–24	22%	30%
25–34	45%	43%
35–54 years old	24%	20%
55+ years old	8%	7%
How heard about the program		
Someone I know told me about it	54%	55%
Museum's website	20%	20%
Newspaper	9%	7%
Extremely likely to recommend to a friend	71%	75%
Came on own	8%	13%
Came with friends	81%	81%
First time visiting Gardner Museum	38%	39%
Been to *After Hours* before	12%	25%
Member of the museum	11%	15%

Second, the survey provided valuable feedback about what was and was not working with *After Hours*, steering the staff's efforts to improve it. This information was critical because the staff tried many activities to engage visitors with the collection, all of which took time to develop and manage. Short, informal activities such as the gallery games and Viewfinder talks were hits, so the staff continued and even expanded them. Others got less traction. When the survey found that few visitors enjoyed the self-guided tours, the team reasoned that the typeface on the tour handout might have been too small to read in the low light of the galleries. They made it easier to read, but even in year two, few survey respondents said the self-guided tours were a highlight of the evening. Recognizing the considerable effort that went into revising the handout to match each evening's theme, the staff dropped the tours so they could spend more time creating new programming. With this kind of data-driven improvement strategy, it's not surprising that *After Hours* attendance grew from an average of 500 visitors each evening in the first year to more than 600 per evening in the second, and almost 700 per evening in the third.

Finally, the survey helped build support for *After Hours* internally. Staff had data in hand showing that the event was attracting young adults who were new to the museum and were experiencing the collection. Some staff members had originally resisted the idea of a social event, particularly one with a bar, but that dissent dissipated once the survey found that the bar played a minor role relative to the art, which captured center stage. *After Hours* continues to this day—albeit with a new name, *Third Thursdays*—and has become an integral part of the museum that has the full support of curators and leadership and is enjoyed by thousands of very satisfied visitors. Visitor surveys continue to be used to help staff profile visitors and understand their experience.

Cost: Gardner's financial outlay was minimal, but museum staff invested significant time to write the survey and enter all of the data into SurveyMonkey. The survey also took up the time of volunteers who administered it at *After Hours*. Indeed, the museum found that if volunteers were not solely dedicated to giving the survey, they became preoccupied with other tasks.

Research Materials: Please see Appendix 1 for the Gardner Museum's visitor survey.

Who's Coming? What Brings Them Here?
The Clay Studio Surveys Its Audience and Finds It Serves More Than One

Research ▶ **The Challenge:** As described in Chapter 2, The Clay Studio believed its future depended on attracting more young people to its programs. It tried several concepts and finally hit upon a winner when it introduced social clay workshops in February 2008. The workshops were marketed as date nights, offering drinks, snacks, and a chance to get your hands dirty at a potter's wheel. They sold out quickly and brought many new people to the studio.

The staff wanted to deepen its engagement with these newcomers, but didn't know who they were or what they wanted from the experience. That wasn't atypical for The Clay Studio at the time. The small organization didn't have a marketing staff, and it had never collected demographic data or done a systematic count of its patrons. But the success of the social clay workshops brought the issue to the fore: **Who exactly was coming to The Clay Studio, and for which activities?**

Research Objectives and Method: The Clay Studio designed a two-page visitor survey with three main objectives. First, it wanted to know if it was successfully attracting a younger audience over time. Second, it wanted to understand traffic patterns and who attended which of its many activities. Lastly, it hoped to find out where visitors lived and how they had heard about The Clay Studio in order to better target neighborhoods with its marketing.

Research Participants and Questions: Starting in February 2008, the staff attempted to give the survey to every visitor, including gallery walk-ins and people enrolled in its classes, traditional workshops, and social workshops. They also handed it out at First Fridays, a monthly open-house event that the studio hosted with other galleries in the Arts District in Old City Philadelphia. The evening routinely attracted as many as 2,000 people, overwhelming staff members who tried to distribute the survey. As a result, First Friday guests were likely underrepresented in the survey sample. The survey gathered demographic information such as age, gender, and place of residence and covered a range of pertinent topics, including how people had heard about

The Clay Studio, with whom they came, what motivated their visit, and how many times they had visited the studio before.

Results: In October 2008, an independent research firm analyzed the 531 surveys that The Clay Studio had collected to date. A separate analysis was completed on 845 surveys gathered in a second data collection period (or *wave*) between October 2008 and June 2010.

Table 8 shows demographic breakdowns of respondents for each wave. Most visitors were women, and on the surface, there appeared to be a good spread across age groups. Importantly, the percentage of visitors ages 25 to 45 rose in the second wave from 44 percent to 55 percent, a statistically significant increase and a sign that the studio was attracting a greater number of younger adults with its social clay workshops. The surveys also confirmed that newcomers accounted for more than one-third of total visitors.

When the staff dug deeper into the data from the first wave, they uncovered interesting differences between first-time visitors and their most frequent patrons. As seen in Table 9, people who had visited The Clay Studio four or more times in the past year tended to be older and to come alone. Further

Table 8. Demographics of Clay Studio Visitors

	Feb 2008–Oct 2008 (n=531)	Oct 2008–June 2010 (n=845)
Gender		
Female	67%	71%
Male	33%	29%
Age		
Under 25	22%	19%
25–45	44%	**55%**
46–64	**26%**	21%
65+	8%	5%
Number of prior visits		
Never before	40%	36%
Once	19%	13%
2–3 times	14%	11%
Four times or more	27%	**40%**

Bolded percentages significantly higher than the other wave at 95% confidence

Table 9. Demographics of Different Clay Studio Visitor Groups

| | PRIOR VISITS TO THE CLAY STUDIO | | |
	4 or more (n=209)	1–3 (n=128)	Never before (n=188)
Gender			
Female	68%	73%	64%
Male	32%	27%	36%
Age			
Under 25	9%	**28%**	**34%**
25–35	30%	**44%**	32%
36–45	13%c	8%	7%
46–54	**17%**	6%	6%
55–64	21%b	8%	14%
65+	11%	6%	7%
Came with			
Alone	**59%**	26%c	9%
Friends	**26%**	45%	51%
Spouse	12%	13%	11%
Children	3%	2%	3%
Others	9%	21%a	**31%**

Bolded percentages are significantly different than all other statistics in the row at 95% confidence

[a] Significantly higher than "Four or more" prior visits at 95% confidence

[b] Significantly higher than "1–3" prior visits at 95% confidence

[c] Significantly higher than "Never before" at 95% confidence

analysis (not shown here) found that they were typically women ages 45 to 64 who lived nearby and had no children under age 18 at home. Meanwhile, newcomers and those who had visited only a couple of times skewed younger and were more likely to come with others, usually friends.

Certain events and programs appealed to different groups of visitors (Table 10). Classes were much more popular among the studio's most loyal patrons, while social workshops had a high concentration of newcomers, suggesting their high degree of effectiveness in drawing new audiences. As the staff intended, the workshops served as both a good entry point for first-time visitors and a reason to return for those who had been to the studio a couple of times.

Table 10. *Clay Studio Program Attendance among Different Visitor Groups*

	Class (n=137)	Traditional Workshop (n=45)	Social Workshop (n=52)	First Friday (n=200)	Walk-ins (n=36)	Other Events (n=37)
Never before	2%	60%	60%	34%	42%	84%
1–3 times	17%	18%	31%	30%	19%	16%
4 + times	81%	22%	10%	37%	39%	0%

The surveys also provided practical information for The Clay Studio's communication strategy. Prior to the research, the organization did not have a clear sense of how people found out about it. In both waves, word of mouth was the top source of information. The second wave also revealed a growing proportion from Internet searches, particularly among digitally savvy young adults.

Acting on the Results: Because of its visitor survey, The Clay Studio had a clear view for the first time of who was coming to its institution and *how* they were participating. It discovered that it served several audiences, from older frequent patrons who came alone, to young adults looking for social, interactive events. The research piqued staff interest in learning more about the newcomers who stopped by on First Fridays or brought a date to a social workshop. They wound up doing additional qualitative research to explore

Table 11. *Sources of Information about The Clay Studio*

	Data Collection Wave		Age (Oct 2008–June 2010)			
	Feb 2008–Oct 2008 (n=511)	Oct 2008–June 2010 (n=810)	<25 (n=156)	25–45 (n=450)	46–64 (n=168)	65+ (n=36)
Word of mouth	56%	54%	**60%**	48%	**60%**	**69%**
Passed by the gallery and shop	**39%**	27%	24%	26%	34%[b]	19%
Internet search	13%	**31%**	26%	**36%**	25%	17%
Advertising	13%	12%	2%	11%[a]	22%[b]	14%
Direct mailings	9%	8%	2%	6%	18%[b]	11%
Print reviews or feature stories	**6%**	3%	1%	3%	6%[a]	6%

Bolded percentages are significantly higher than the other wave or all the other age groups in the row at 95% confidence

[a] Significantly higher than <25 at 95% confidence
[b] Significantly higher than <25 and 25–45 at 95% confidence

what these new younger visitors wanted from the experience and how to get them to come more often.

On a tactical level, the survey helped the studio market itself more effectively. The staff studied ZIP codes to identify where its visitors lived, then targeted those neighborhoods by distributing its marketing materials in places that culturally active young adults tend to frequent, such as coffee shops, art galleries, yoga studios, and Whole Foods grocery stores. Neighborhoods often attract like-minded and demographically similar people, the staff reasoned, so it was probable that other people living there would also find its events appealing. The staff also gained the confidence to do more digital marketing, given the survey finding that visitors were increasingly going online for information. That move has saved the organization tens of thousands of dollars a year in printing and postage costs.

Cost: About $14,000. The Clay Studio hired a market research professional to design the survey and a market research firm to tabulate responses and produce a report with charts for both waves of data collection. Staff distributed and collected the survey themselves.

Research Materials: Please see Appendix 1 for The Clay Studio's visitor survey.

Guidelines for Using a Survey to Track and Assess Results

Guidelines ▶ Doing a survey doesn't require a degree in marketing or statistics, but you will have to make several key decisions about its design. You also need to develop (and stick to!) a plan for administering it to ensure it delivers reliable results. A research professional can help, or you can do it on your own by following the guidelines that follow. What's critical is thinking through the entire research project at the outset to make sure it will meet your objectives. In other words, don't wait until the survey is being given to decide how you're going to *use* the data. Writing a research brief can help you organize your thoughts. It's a document that outlines your objectives, your plans for executing the research and how you will use the results. You may not have all the answers at first, but you can fill them in as decisions are made. It's worthwhile to share the brief with others in your organization who aren't directly involved with the research but whose work will be affected by the results. Their input may lead to new research topics to explore. It also helps build buy-in for the project so the findings will be embraced once it is complete. For more on research briefs, please see page 109.

There are three main tasks in conducting a simple survey to track and assess program results. First, you have to design the survey, including which questions to ask and how. Next, you have to decide how to administer the survey and who will take it. Finally, there's the analysis of the data. Each of these areas is covered below.

Designing a Survey

1. What to Ask: Questions That Tell You Who Is Coming and Why

The questions you ask depend on the objectives of your audience-building initiative. Clearly articulate what defines success for your program—who is visiting, in what context, and having what kind of experience—and build a survey that measures those elements. For instance, you may want to know what

motivated newcomers' visits and whether they enjoyed themselves enough to consider coming again. Goals will differ across programs, but there are some topics germane to many surveys tracking the progress of audience-building initiatives.

Visitor characteristics

- Demographics, such as age, gender, and ethnicity
- Relationship to your organization—e.g., are they first-timers, infrequent or frequent visitors, members or nonmembers, subscribers or non-subscribers

Visit context

- Whom did they come with? This information can tell you, for example, whether the responder considers the visit a date night, social outing, or family time.
- Reason for visit—what specifically were they looking to do or experience?

Visitor experience

- What did they do or see on their visit (if multiple activities are available)?
- How did they prepare for their visit—did they review information on your website, for instance, and how suitable was that preparation?
- Length of stay (for museums, galleries, and other spaces that do not have set program times)
- Enjoyment of visit and/or different elements of it
- Interest in returning
- Likelihood of recommending the organization to others
- Suggestions for improving the experience

Promotion/marketing

- How they heard about the institution, event, or program

This list suggests many possible questions, but it is important to resist the temptation to ask everything. There is *always* a trade-off between the number of questions you can ask and the number of people willing to complete the survey. A long survey can impair your ability to collect data from a representative sample of your audience (discussed later in this chapter). Others in your organization may be tempted to add questions, as well. While

> **There is always a trade-off between the number of questions you can ask and the number of people willing to complete the survey.**

you will likely want to incorporate their perspectives, it's important to stay disciplined and keep the questions directed toward your audience-building objectives. Avoid asking unrelated ones just because you're already doing the survey. It might be interesting to know what other cultural activities your new visitors enjoy, for instance, but are you prepared to act on that information?

2. Question Format: It's Not Just What You Ask but Also How You Ask It

When surveys are easy to follow, respondents give reliable answers that reflect their true experience as you hope to understand it. Different formats are suited to different kinds of questions.

Multiple-choice questions are useful when responses are likely to fall into specific categories, such as demographics or other straightforward facts. They're easy for people to answer—they just tick a box—and the results are simple to summarize and analyze. The only trick is making sure that the answer choices cover all possibilities. If that's not possible, include a write-in option, as shown in Example A.

It's important that the choices be mutually exclusive, to avoid confusion when respondents answer the question and when the data are being interpreted. If Example A had an additional option, "I'm here with a family member," a respondent who came with only a spouse might check that box in addition to checking "I'm here with my partner or spouse," perhaps making it appear as if he or she came with more than one person.

Example A

Who are you visiting with tonight? (Check all that apply.) ☐　　I came on my own ☐　　I'm here with friends ☐　　I'm here with my partner or spouse ☐　　Other (please specify) _____

Scaled questions are also intuitive for respondents, and are a good way to measure beliefs and attitudes. In a survey tracking outcomes, a rating scale is often used to gauge satisfaction, enjoyment, or other dimensions of the visitor experience. Respondents answer along a continuum typically having five options, including an in-between rating (Example B) or a neutral rating (Example C). How many points to include is up to you, although many market researchers prefer fewer than 10 and an odd number (such as 5 or 7) to allow for a midpoint for neutral responses. Labeling the points in a way that divides the range into approximately equal units will help respondents answer more accurately.

A *semantic differential* scale is used to evaluate different qualities of the visitor experience by labeling the endpoints with contrasting adjectives, as in Example D. Display all of the adjective pairs in a consistent way throughout the list of questions to make it easy for respondents to follow. In this example, the least-intense endpoints are all on the left and the most intense are on the right. You could also use more positive terms on the right and negative ones on the left, so that answers toward the right indicate a more positive evaluation.

Example B. Please rate each of the following:

	Poor	Fair	Good	Very Good	Excellent
Overall visit	O	O	O	O	O
Parking availability	O	O	O	O	O
Ease of ticket purchase	O	O	O	O	O

Example C. How satisfied are you with each of the following? (Please place a check mark in one circle in each row.)

	Not at All Satisfied	Satisfied	Neither Satisfied nor Dissatisfied	Very Satisfied	Extremely Satisfied
Overall visit	O	O	O	O	O
Parking availability	O	O	O	O	O
Ease of ticket purchase	O	O	O	O	O

Example D. How would you rate your visit along the following dimensions?
(Please place a check mark in one circle in each row.)

Inexpensive	O	O	O	O	O	Expensive
Impersonal	O	O	O	O	O	Welcoming
Boring	O	O	O	O	O	Captivating

Open-ended questions let people answer freely, as shown in Example E. They're good to include at the end of a survey because they can surface valuable information that is not captured elsewhere. That said, including more than one or two is not advised. Respondents are prone to skip them more than multiple-choice or scaled questions, and sometimes their answers are not clear. Open-ended questions take more time to analyze, too (see "Analyzing a Survey" on page 105).

Example E

> What could we do to improve your visit?
>
> _____
>
> _____
>
> _____

3. Question Writing: Some Dos and Don'ts

Many people simply write survey questions that make sense to them without considering how others might interpret them. That's a problem, because respondents might attach different meanings to a question, leading to survey results that don't provide clear direction or, worse, are misleading. Question writing is an acquired skill that many survey researchers spend years honing. You may want to tap their expertise if your budget allows.

You can write the questions on your own, as long as you keep in mind that you're speaking with an audience who may not be as conversant or interested in the survey topics as you are. The meaning of each question should be crystal clear on the first read. Several examples of surveys are included in Appendix 1. You can borrow from them, but be sure to adapt them to fit your specific needs. Here are some general writing guidelines to follow:

Drop the jargon. Terms like *artistic programming* may roll off your tongue, but they will likely leave many survey respondents scratching their heads. (You might not even realize you're using insider lingo until you test the questions with someone from outside of your organization, as described below.) Instead, use language a layperson can easily understand, such as *gallery tours* or *the productions presented this season.*

Talk numbers. Words such as *frequent* and *occasional* are open to interpretation. Instead, ask respondents to quantify, for example, their visits to your organization within a specific time period. It will give you a clearer read of who is visiting and how often, as shown in the following examples that each have a slightly different focus.

- How many times, including your visit today, have you been to the museum?
 - a. 1
 - b. 2–3
 - c. 4–5
 - d. More than 5
- How many times in the past year (including today) have you attended productions at this theater?
 - a. 1
 - b. 2–3
 - c. More than 3
- How many productions do you attend at this theater in a typical year?
 - a. 1
 - b. 2–3
 - c. 4–5
 - d. More than 5

Ask one question at a time. In the interest of keeping the survey brief, or perhaps unintentionally, you may wind up with questions that ask more than one thing. Asking respondents to judge a statement such as, "Ticket purchase was fast and convenient" might elicit more than one thought if they think speed and convenience are two separate things. Decouple double-barreled questions (into, e.g., "Ticket purchase was

fast" and "Ticket purchase was convenient"), or ask only the one you really mean.

Stay positive. Negative statements can be confusing, particularly if you're asking respondents the extent to which they agree or disagree. "It's difficult to find parking," or "The brochure doesn't have enough information about class content" may elicit more agreement from survey takers than is actually reflective of their opinion. Positive statements such as, "It's easy to find parking" or "The brochure clearly explains what is covered in each class" tend to work better. Avoid using the word "not," too. Statements that contain it can be misread or misheard.

Be brief. A question that is wordy or has multiple clauses can trip up people, leading them to skip it or answer in a noncommittal way (e.g., by selecting a neutral response or just agreeing for the sake of agreeing).

4. Question Order: Go with the Flow

Surveys that flow naturally from one question to the next are easier for people to follow and answer. The first few questions set the tone. Questions with a definitive answer (e.g., "How many people are you visiting with?") work well at the beginning because they signal to respondents that they have the necessary knowledge to take the survey. Remember, many new audiences find arts organizations intimidating. They may find taking a survey even more so, or feel that they're not the right person to answer questions about the experience. Save questions that require more thought for later, when respondents have built up their confidence and are somewhat invested in finishing the survey. Asking them up front may cause people to abandon the survey altogether.

Arrange questions according to topic, and when it's time to move on to a new subject, include a brief transition statement just as you would in conversation. It can be as simple as, "Now we'd like to know what you did while visiting."

You'll likely want to collect demographic data, and market researchers often advise asking for that information at the end of a survey, for a few reasons. First, people may be reluctant to answer questions about their age or ethnicity if they've encountered any kind of bias in the past. (Note that even

if someone leaves demographic questions unanswered, you can still include their other responses in your analysis.) In addition, when organizations invite visitors to take a survey, they typically explain why they're doing the research. Beginning with demographic questions will appear misaligned with those objectives.

5. Take It for a Test Drive

Whether you write the survey yourself or enlist the help of a professional, test it with a few people from outside of your organization before going further. Listen closely to their feedback as they take the survey and you'll get a good sense of whether they're interpreting the questions as you'd intended. They can also tell you if multiple-choice options cover all the bases and the relative ease or difficulty of completing the survey.

Giving a Survey and Determining Who Takes It

The objective of survey research is to get a profile of an audience. The first step is to specify which audience you want to track and monitor. Survey researchers call this your *population*. In most cases, organizations track changes within their overall audience, e.g., "anyone who comes to a performance" or "anyone who visits the museum during opening hours year-round." Sometimes, an arts group may want to monitor visitors to a particular audience-building program. The Isabella Stewart Gardner Museum provides one such example, described earlier in this chapter.

It's unrealistic to expect that all members of your population will complete a survey. Only a subset will, comprising what researchers call a *sample*. Your sample should look like a miniature version of the population you want to track. Good samples don't just happen. A *sampling plan* lays out how you're going to make it happen. Yes, preparing this adds an extra step, but given the amount of time you spent designing your survey and the data's potential impact on your decision making, it's well worth the effort to ensure that you get an accurate and unbiased portrait of your audience. For your sampling plan, you'll need to decide how many people you will want to complete the survey—that's the final sample, often called simply the *sample*. You'll also

need to decide where and when they'll take it, and how they will be selected to participate. Each is covered below.

1. Sample Size: How Many People to Survey

Generally speaking, the larger your sample is, the more confident you can be that the results accurately reflect the tendencies of your audience overall. But there's a trade-off: More time and money are needed to survey more people, so large samples are rarely the most practical. Market researchers like to have a minimum of 200 to 250 people answer a survey. That may seem like a lot, but the results you obtain from a survey with a sample of even that size are likely to be only good—not exact—indicators of the entire population.

For example, say you want to estimate the percentage of women in an audience of a few thousand people. If women make up 70 percent of the respondents in a survey completed by 250 audience members, it is very likely that women outnumber men to a great extent in the audience as a whole. The percentage of women isn't likely to be 70 percent on the dot, but somewhere in that neighborhood. Without having the entire audience complete surveys, it is impossible to know the exact percentage, but you can gauge how precise that 70 percent estimate is through the *margin of error*. The margin of error indicates how much an estimate could potentially differ from the actual number. For example, if a pollster says that 40 percent of people favor a certain candidate but the margin of error is 4 percentage points, that means the actual percentage of people favoring the candidate lies somewhere between 36 and 44 percent. (The range defined by the margin of error is calculated to be wide enough that it will capture the true value 95 percent of the time. This is called *95 percent confidence.*)

Market researchers rarely calculate the margin of error themselves, but instead consult tools like Table 12 below, which shows margins of error for various sample sizes and survey results (in the form of percentage points). Note that the margin of error is a function of both the sample size and the survey result in question. It is smallest when sample sizes are large. That makes sense—the more people you survey, the more closely the results will reflect your audience's actual characteristics. The margin of error also drops as a survey result moves in either direction from 50 percent. Extreme values, such as 10 percent or 90 percent, have a tighter range around them. To find a margin

of error for a survey result, simply find the row that's closest to your sample size and the column that's closest to your result. Taking the example above, if 70 percent of the respondents in a survey of 250 people are women, then the margin of error for that result is 5.9 percentage points. In other words, you can say with 95 percent certainty that the true percentage of women in the audience falls somewhere between 64.1 percent and 75.9 percent.

How do you decide the right sample size for your survey? Strive for one with a margin of error you can live with based on how feasible (and expensive) it is to get surveys completed. A sample size of 400—which has a margin of error of 4 to 5 percentage points in most cases—is a good compromise. If you are only interested in the results of the sample as a whole, you can go as low as 250. However, if you want to contrast and compare the results among different groups within your sample, you'll need a larger sample (market researchers typically aim for 100 respondents per subgroup, at a minimum). A sample that large might not be attainable for an organization with a very small audience or one that is trying to assess a small program. In such situations, you might have to be content with a sample of 50 or 60 people.

Table 12. Margin of Error at 95% Confidence

	SURVEY SAYS					
	5% or 95%	10% or 90%	20% or 80%	30% or 70%	40% or 60%	50%
50	7.2%*	9.5%*	12.4%	14.0%	14.9%	15.2%
100	4.8%*	6.5%	8.4%	9.6%	10.2%	10.4%
150	3.8%	5.1%	6.7%	7.7%	8.2%	8.3%
200	3.3%	4.4%	5.8%	6.6%	7.0%	7.2%
250	2.9%	3.9%	5.2%	5.9%	6.3%	6.4%
300	2.6%	3.6%	4.7%	5.4%	5.7%	5.8%
400	2.3%	3.1%	4.0%	4.6%	4.9%	5.0%
500	2.0%	2.7%	3.6%	4.1%	4.4%	4.5%
600	1.8%	2.5%	3.3%	3.8%	4.0%	4.1%
800	1.6%	2.1%	2.8%	3.2%	3.5%	3.5%
1000	1.4%	1.9%	2.5%	2.9%	3.1%	3.1%
2000	1.0%	1.3%	1.8%	2.0%	2.2%	2.2%

Source: Calculated by author using the Wald formula with continuity correction (values marked with an asterisk are combinations of extreme probability and low sample size, for which the estimate is less accurate).

2. Representative Samples: Talk to the Right People

Regardless of its size, your sample has to be representative of the audience you want to understand in order for the survey results to accurately reflect it. In fact, a well-constructed sample of 150 respondents can be more reliable than a poorly constructed one several times that size. This fact is, unfortunately, ignored much of the time. Examples abound of surveys with large samples obtained using the most convenient method of collecting data, but not necessarily a valid one, guided by the false notion that a large sample will ensure that survey results accurately reflect audience tendencies.

The biggest potential problem is *sampling bias*, which occurs if some visitors have a greater chance than others of being selected to take a survey. As a result, their opinions get overrepresented, while those of others are underrepresented. The best way to avoid this is by using a random sample—picking people on a completely random basis to take the survey, giving everyone in your audience an equal probability of being included.[8] Don't be fooled by the word *random*—it doesn't mean leaving the sample to chance or proceeding without a plan. A random sample results from having specific procedures in place to ensure that one person does not have a greater chance than another of being chosen to take a survey.

In practice, it's rarely possible to create a truly random sample of an audience. That's because, in order to ensure that everyone has an equal chance of being selected, you would have to know who they all are and how to contact them, and then some would be selected at random to take the survey. Most organizations cannot meet these conditions. Although they may have a database of members or ticket buyers, those lists, even if current, exclude the large swaths of visitors who come as guests or have a ticket bought for them by some other means. Despite these limitations, it is still possible to obtain a high-quality sample by thinking through how all audience members can have an equal chance of being selected (to the extent possible), and following procedures that reduce the potential for sampling bias.

8. In fact, margin of error statistics like those in Table 12 assume that the statistics being evaluated come from a random sample. It is not possible to know how close survey results from non-random samples are to the actual values they are supposed to indicate.

3. Location, Location: Conducting a Survey On-Site to Capture the Full Audience

An on-site survey is one of the best ways to reach your entire audience because they are right there. It's more difficult to get them after the fact, especially if you're trying to include newcomers, who aren't likely to provide their contact information when they visit. (An online survey is an option, particularly if you have lists of potential respondents from ticket or membership databases, but it has drawbacks. See sidebar, *The Pros and Cons of Online Surveys*.) On-site surveys also let you capture people's immediate impressions of their visit if that's what you're interested in. Their memories of the gallery tour or performance are still fresh, leading to survey responses that best reflect that experience. On-site surveys can be done in two ways: self-administered or face-to-face.

Self-administered surveys are questionnaires that people fill out themselves. The easier the survey looks, the more people will be inclined to complete it, so pay close attention to the layout. Keep it to one page, or even a postcard if you can fit all the questions without resorting to using small type. If you use a two-sided sheet, indicate clearly that the survey continues on the reverse side. Make use of white space—heavy text can make a survey look time-consuming—and give the survey a professional appearance by formatting it carefully; if respondents don't think you've devoted much time to the survey, they will be less inclined to give their own. The survey should start by thanking the individual for participating and explaining who is conducting the research and why. It should also note that responses are anonymous, and give instructions for returning completed surveys. It could read something like:

> *Thank you for taking the time to help staff at the Theatre create a better visitor experience. Please answer the questions on your own. For the survey to be valid, we need just one person's perspective (yours!), so please don't ask others who may have come with you for their opinions. Please return your completed survey to a volunteer with an "Ask Me" badge or place it in one of the boxes marked "Visitor Surveys" in the lobby.*

There's also the question of timing: When should visitors take a self-administered survey? A survey that asks about a person's experience obviously

▶ THE PROS AND CONS OF ONLINE SURVEYS

On-site surveys have some limitations. First, visitors are unlikely to complete a long questionnaire; after all, they are there to enjoy themselves, perhaps with friends or family, and the survey will be an interruption. Second, administering on-site requires dedicated staff, volunteers, and possibly professional interviewers. Even a self-administered survey needs sufficient staff on hand to answer questions respondents may have. There's also the issue of crowd control: intercepting audience members at a performance or event where a large number of people leave at the same time can create a bottleneck at the exit doors.

Online surveys are a popular alternative, given their easy administration and relatively low cost. A number of do-it-yourself tools, such as SurveyMonkey (www.surveymonkey.com), make it quite simple for anyone to field a survey. That said, the method usually will draw only a limited portion of your audience. In order to field an online survey, you must invite respondents to participate. That means your potential respondents are limited to the people who are in your database and who have provided a valid e-mail address, possibly when they bought tickets. You'll miss everyone else in your audience, including walk-ins and guests of ticket buyers. That might be fine if you're only interested in surveying ticket buyers, subscribers, or members, but it's a serious limitation when you're trying to understand the experiences of all attendees. A survey distributed at the box-office window will have a similar bias—it will only represent the opinions of ticket buyers.

You can handle this problem by collecting e-mail addresses from attendees during brief on-site interviews, then following up with an e-mail invitation to the survey later. It's a risky strategy, however, because many people are reluctant to share their e-mail addresses. That can be especially true of newcomers, who may be intimidated by arts groups or think they don't know enough to participate. You will likely get a high refusal rate. Don't even consider having a sign-up sheet or leaving cards out for people to complete. While that may build your e-mail list, it won't deliver a representative sample of your audience because most visitors won't volunteer their information, even with some cajoling.

has to be taken at the end of the visit. Distributing it as people arrive and asking them to complete it later won't work. Visitors might read the survey beforehand, which could sensitize them to certain things during their visit or otherwise influence their answers. You also risk surveys being forgotten in purses or pockets. For organizations such as museums and galleries that have a constant flow of visitors, staff or volunteers can ask people on their way out to take an "exit survey" before they go. Performing arts organizations can do the same, but it can become unwieldy because everyone in the audience leaves at the same time (and many will be in a hurry). To avoid congestion at the exit doors and encourage participation, the survey should be extremely short—no more than a few multiple-choice questions—with ushers or volunteers on hand to distribute and collect them as they are completed.

There are some alternatives. It's possible to distribute a longer survey with a business-reply envelope and ask attendees to mail it back, but this methodology can add complexity and cost. A more popular approach is to e-mail a survey to ticket buyers for whom you have e-mail addresses. Keep in mind, however, that responses will come from ticket buyers themselves, and you'll miss their guests as well as those ticket buyers for whom you do not have contact information.

Timing is less of an issue when a survey doesn't ask about the audience's experience per se, but instead focuses on demographic information or how people heard about an organization or event. In that case, performing arts organizations can distribute the survey beforehand by either attaching it to ticketed seats or including it in programs (preferably on off-size colored paper to make it stand out). Staff or volunteers can travel the aisles to collect completed surveys before the show or during intermission. They should be easily identifiable (e.g., wearing badges) and be familiar enough with the survey to answer questions about it in a friendly, informative way. They should also know how the survey is being used so they recognize the importance of proper administration. (For additional tips, see box, *Six Ways to Boost Your Response Rate*, on page 103.)

Face-to-face interviews tend to be used by organizations such as museums that have an open flow of traffic throughout the day. With this method, a staff member or research professional "intercepts" a visitor and invites him

or her to take a brief survey. They should use a standard introduction that explains who is conducting the survey, for what purpose, and how long the interview will take. If the visitor agrees (and most will), the interviewer proceeds with the survey and records the person's answers on a blank questionnaire. The questionnaire should be easy for the interviewer to follow to allow for a smooth interview that doesn't take more time than necessary. And, of course, respondents should be thanked when the interview is done. Multiple interviewers may be on-site at any one time, stationed in different areas to increase productivity.

Interviewers play a critical role because they both select respondents and ask the questions. If your budget permits, professional interviewers are definitely an asset. Staff members and volunteers can do the job too, but you'll need to dedicate time to training them. The project leader should walk the interviewers through the survey, explaining the intent behind each question and how the data will be used. Practice is a must. Interviewers should have complete facility with the questionnaire and be able to move through it objectively (see sidebar, *Objectively Speaking*). Have them take turns administering the survey to each other, not only for practice but also to understand the perspective of respondents. Training should also cover the importance of systematic random sampling (discussed later).

4. All in the Timing: When to Do an On-site Survey

An on-site survey needs to be done on several occasions so you don't bias the sample toward one kind of respondent. It's an important step because an audience can vary from one day to the next, as a function of the time of year, day of the week, programming, or even random factors like the weather. At any given time, only a portion of your audience is present—and that portion may not be representative of the rest who attend at other times. For instance, an opera company presenting both traditional and contemporary repertoire might find (or at least suspect) that those genres appeal to different groups of people. A museum that has exhibits, workshops, and classes may find that each draws a unique audience looking for a different experience.

Even the same program can attract a different audience at different times. A theater company might draw more seniors to its weekday performances

▶ OBJECTIVELY SPEAKING

Interviewers can introduce bias unintentionally (known as *interviewer bias*) when their actions or comments lead a respondent to answer in a certain way. Professional researchers are trained and practiced in avoiding this bias. If you're using staff or volunteers to conduct interviews, ensure they are well versed in the following practices:

- **Keep a poker face.** Interviewers shouldn't show any reaction to responses, such as surprise, agreement, or disagreement. In the rare instance of encountering a dissatisfied visitor, they should resist the temptation to try to make amends during the interview itself. Instead, a response of "I see" is appropriate, and at the end of the interview, they can express concern and direct the guest to an appropriate staff member.
- **Stay on point.** Volunteers and staff are often very passionate about their organizations, but they need to keep that enthusiasm in check during the interview. Sharing personal observations or engaging in conversation can influence responses.
- **Bite your tongue.** It's a natural tendency, and sometimes automatic, to finish a respondent's sentence, but interviewers need to be aware that even if they're trying to be helpful, doing this can compromise response validity.

when tickets are less expensive, and more middle-aged professionals and younger couples on the weekend. If staff members fielded the survey only on weekdays because that's when they had the time, they would bias the sample by over-representing the opinions of older patrons. Instead, the sample should include both weekday and weekend audiences in proportion to their actual attendance patterns.

One way to get past this hurdle is to administer the survey whenever you're open to the public. That might make sense for an organization with 20 or fewer performances a year or one that is surveying participants in a program that runs only occasionally, such as once a month. But organizations that have more frequent performances or receive visitors over several hours

every day, such as a museum, might find this approach too difficult to manage. They'll want to select particular times to survey that, when taken as a whole, capture variations in their audience due to programming, day of the week, or other factors. Arts groups are not alone here. Tourist destinations, shopping centers, and other organizations that serve a wide variety of visitors at different times grapple with the same issue when conducting surveys.

To capture this variation, you must first consider all of the occasions that your organization is open to the public. A dance company, for instance, could count each of its performances as an occasion. An art studio that offers classes and workshops might count each of those. Organizations with a more open flow of traffic, such as a museum or gallery, might define a time period as brief as a half hour or as long as an entire day.

Once you've mapped out all possible occasions, select a variety of times to administer the survey that will capture the different audiences coming through your doors. You'll most likely want to include different days of the week and different times of the year. Organizations with opening hours should survey at different times of the day, too. Those with multiple activities that attract different people, such as an art studio offering workshops and exhibits, will want to sample across them.

There are many ways to do this, but you want to end up with a selection that meets two criteria. First, there should be a broad enough range to capture variations in your audience due to time, activity, or programming. Second, you should conduct the survey at the same type of occasion several times to catch natural variations in your audience that are due to random or unknown factors. In other words, a museum shouldn't survey visitors only on one Tuesday morning, but rather on many Tuesday mornings over a period of time.

Say, for instance, that a theater company is doing a survey to gauge whether its audience-building initiative is drawing younger patrons to its shows. It presents 10 performances of five plays each season, with a total of 20 weekend and 30 weekday performances. The staff believe that weekend and weekday patrons have different demographics. One option would be to collect 10 completed surveys at each performance, for a total of 500 surveys. Such regular, steady assessment throughout the year is perhaps the best way

to deliver a representative sample. But say the organization only had the resources to survey at select performances. It could still get 500 surveys by choosing two weekday and two weekend performances of each production (a total of 20 sampling occasions) by aiming for 25 completions each time. If it tends to get a larger audience on the weekend, it could aim for more completed surveys from weekend attendees than weekday ones so that the sample matches actual attendance patterns. Don't worry if the proportions of your completed surveys are off a little once you've finished collecting data; it's not possible to control that completely. When it's time to analyze the results, you can weight the data so that different subgroups have the representation that you think they should (note that you may need a professional market researcher to help with this).

5. Choose Carefully: Selecting Audience Members to Take a Survey

Even after selecting a variety of occasions to survey, the possibility of favoring one kind of respondent over another still exists. Say, for instance, that the theater company had a group of young volunteers approaching patrons to take its survey. If those volunteers favored younger patrons over older ones, or people who just looked more approachable, they would introduce bias into the sample.

The potential for bias can be reduced by following *systematic random sampling* rules. For an on-site survey, that can entail abiding by an "every *n*th" rule whereby every *n*th person in the audience is asked to complete the survey. How that's managed depends on how you are administering the survey. Performing arts organizations distributing a survey before a performance can insert it in every *n*th program or attach it to every *n*th seat for which a ticket has been sold. Class instructors at an art studio can leave the survey on every *n*th seat or ask every *n*th student on their roster to fill it out. Museum volunteers who are distributing surveys or doing face-to-face interviews can approach every *n*th person who crosses a certain point.

To figure out your *n*, start by dividing your expected attendance by the number of completed surveys you hope to reach. Keep in mind that not everyone who gets a survey will fill it out—a good estimate for a response rate is 40 percent for self-administered surveys and 80 percent for face-to-face

interviews (discussed further below).[9] For example, say the theater company mentioned earlier wants to obtain 25 completed self-administered surveys at a particular performance and expects 300 people to attend. It would compute the n by dividing 300 by 25, then multiplying the result (12) by 40 percent, or 0.40, to arrive at 4.8. Rounding up, the staff would leave the survey on every fifth seat or insert it into every fifth program. In all, it would distribute 60 surveys in hope of getting 25 completions.

The task is less straightforward for face-to-face interviews because you have to consider the time it takes to interview someone. How many interviews you can complete will depend on traffic flow and the number of interviewers. In this case, you'll have to estimate.

Sometimes, audience members volunteer to take a survey or be interviewed. While it's refreshing to see such enthusiasm, including *self-selectors* in your sample will likely lead to an underrepresentation of people who do not know your organization well—they will opt out because they think they're not enough of an "expert" to complete the survey. Some researchers politely decline the offers of self-selectors, while others let the person take the survey but mark it so it's excluded from the final results. This may seem wasteful, but you are preserving the integrity of the random sample in order to obtain a reliable audience profile.

People may *deselect* from surveys, too. For example, if an interviewer following an every-nth rule approaches someone and that person defers to someone else—perhaps by saying something like, "You better ask my friend, he knows a lot more about this than I do"—that person is deselecting. The person you ask must be the one who takes the survey. Here, it helps to remind the prospective interviewee that all opinions are valid, and that they have been randomly selected to participate. If the person still refuses (and some will), simply move on to the next nth person.

6. Quality Control: Monitor Response Rate

The response rate is the percentage of people who complete a survey among those who have been offered one. Don't confuse it with the percentage of

9. These are estimates of the response rate (discussed below) for sample estimation purposes, but may be conservative because there are ways of increasing them.

audience members or visitors who have taken a survey, which will likely be lower because, in most cases, not everyone gets the chance to fill one out. A higher response rate tends to indicate lower self-selection biases and a more representative sample, so it's advisable to monitor it. There are no hard-and-fast rules about what is acceptable, but generally speaking, self-administered surveys *at a minimum* should garner a response rate in the range of 35 to 50 percent. Although many organizations accept those rates (or lower) because achieving them is feasible, museum evaluation and audience development expert Marilyn G. Hood has suggested a two-thirds response rate as a minimum. That can be attained with dedicated effort, and is in consensus with recommendations by several leading survey research experts.[10] The response rate for face-to-face interviews is usually much higher, about 75 percent or more.

If your response rate is low, your sample may be biased and not representative of your audience. For instance, if a museum's visitor survey is getting only a 15 percent response rate, it may be because only the institution's biggest fans think it's worthwhile to complete it, potentially biasing the results in favor of their opinions. Or, if many people are declining to be interviewed, it may be due to a language barrier or some other factor. These problems need to be fixed. By monitoring your response rate, you can spot these issues early on and find creative solutions that boost audience participation (see, *Six Ways to Boost Your Response Rate*).

7. Quality Control: Stick to the Plan

Sticking to a sampling plan is critical when you want to track changes in audience composition or behavior over time. In fact, in evaluating programs, that's the kind of comparison you're most likely to be interested in. But if you use a different data collection method from one *wave* of a tracking survey to the next, you may not be able to make comparisons—any changes that you find over time could be a function of where and how you gathered the data.

It sounds implausible, but even small changes can make a large difference. Say, for example, that the theater company described earlier fields its survey again next season because it wants to track how well its initiative builds a

10. Marilyn G. Hood, "High Response Rates Are Critical to Museum Audience Research," *Visitor Behavior* 11 (1996), 15-18.

TIP ▸ SIX WAYS TO BOOST YOUR RESPONSE RATE

1. Have pens or small golf pencils handy for patrons who need one.
2. Use a large font on the survey so it's easy to read.
3. Prepare your staff or volunteers. Tell them how the survey data will be used so they can answer questions in a concise and friendly way.
4. Offer a prize. When patrons fill out the survey, enter them in a drawing for a special gift. (Resist the urge to give away performance tickets or something related to your organization. That will be more of a motivation to people who are already your fans, biasing the survey in their favor.)
5. Advertise. Performing arts organizations should post notices and make announcements about the survey before the performance and during intermission.
6. Hold the curtain. Performing arts organizations distributing a survey in programs or attached to seats might consider a brief delay so last-minute arrivals have time to complete the questionnaire before the performance.

Museum evaluation and audience development expert Marilyn G. Hood offers other tips to increase response rates that apply in a wide variety of visual and performing arts contexts, including: (1) emphasizing issues of importance to the targeted audience; (2) stressing that participation will help the organization do a better job in the future; (3) emphasizing anonymity; (4) making the invitation personal (e.g., "You are important to us, and have been selected by our sampling procedure"). See Hood (1996), 18.

base of younger patrons over time. The staff doesn't follow the same sampling plan and instead leaves copies of the survey in the lobby for people to take as they wish. Not only does the staff increase the risk of a non-representative sample—longtime patrons may be more likely to fill out the survey than first-time visitors or novices—but also the kinds of people who take the survey in the second year will probably differ in some ways from the random (and more representative) sample of all audience members who took it in the first. The organization won't be able to make legitimate comparisons between the two waves of the survey, defeating its goal.

Similarly, if you're surveying visitors in a variety of settings and want to track changes in your audience over time, strive for consistent data collection. Distribute the survey at the same classes or events for each wave, or set up a schedule so they're handed out at the same time of the day on the same day of the week, preferably several times. If that's not feasible, make sure to weight your totals by event when tabulating the data. This kind of consistency is not always possible; programming, course offerings, repertoire, and schedules can change from one year to the next. When that happens, revisit your original sampling plan and determine if it still captures your audience. Adjust it if it does not, keeping in mind that some fluctuation in your results may be due to different kinds of programming.

TIP Do a trial run with your survey to test the methodology. Make sure that respondents find it easy to fill out—you'll know if they ask questions or leave blanks—and that your response rate is at least 35 percent for a self-administered survey, or at least 75 percent for a face-to-face one. Then you can make any necessary adjustments before fielding the survey for data that you'll want to use. This step is especially important with a tracking survey. If you treat your first—baseline—survey as the trial run, you risk taking this important measurement without having perfected your method. If you change the methodology to improve response rates or other elements, that could compromise the validity of comparisons from one wave to the next.

Analyzing a Survey

1. Turning Completed Surveys into Data

Survey responses must be entered into a computer and transformed into a data file before they can be analyzed. There are a few ways to do this. One option is to enter responses in a spreadsheet program such as Microsoft Excel or a statistical software program such as SPSS (which is more expensive). Using spreadsheet and statistical software requires some expertise, which is why many organizations get professional help, especially when their volume of surveys is high or the analysis complex. Data are typically entered one respondent per row on a data spreadsheet, and each column corresponds to a particular survey question.

Data entry requires converting survey responses into numeric codes. Assigning codes for multiple-choice and scaled answers is straightforward, as shown below. The multiple-choice options in Example A are coded 1 through 4, while the scaled responses in Example B are coded 1 through 5. You'll also need to specify a code for missing data (researchers often use 9 or multiple 9s if more spaces are required, unless *9* is actually a meaningful response). Once all the data are entered according to their numeric codes, you can create charts and graphs of the results depending on the capabilities of your data analysis software.

Alternatively, you can re-create the questionnaire online using a platform such as SurveyMonkey and input each completed survey, one by one. Numeric codes aren't necessary since the platform does that back-end work. Online survey platforms have built-in tools for creating charts and graphs that are much more intuitive than most spreadsheet and statistical programs, and

Example A

> Who are you visiting with tonight? (Check all that apply.)
> **1** ☐ I came on my own
> **2** ☐ I'm here with friends
> **3** ☐ I'm here with my partner or spouse
> **4** ☐ Other (please specify) _____

Example B. Please rate each of the following:

	1	2	3	4	5
	Poor	Fair	Good	Very Good	Excellent
Overall visit	O	O	O	O	O
Parking availability	O	O	O	O	O
Ease of ticket purchase	O	O	O	O	O

they can be used for little or no cost. What's more, many let you export the data to spreadsheet programs for more sophisticated analysis if you decide to go there.

Open-ended questions take a bit more work to analyze because you'll likely get many different answers. A question such as, "What could we do to improve your experience?" might yield written comments about parking, programming, ticket price, or other issues. You'll want to group responses into categories to make them easier to understand and analyze. The first step is to identify the major themes that are raised. You can do this by reviewing a sample of responses—10 to 20 percent of all completed surveys, or a minimum of 50. Assign numeric codes to all of the themes that account for more than 5 percent of responses (e.g., 1 = "parking," 2 = "front-of-house experience," 3 = "ticket purchase," etc.). The codes should be clear enough that two people reviewing responses would put most of them in the same categories. That may take some iteration in developing the coding scheme and discussion among the people coding the actual responses. Once you feel confident that your coding scheme reflects the major themes being raised, you can review all of the written responses and categorize them according to the code. Keep in mind that a single response may touch upon multiple themes—a respondent might cite parking, pricing, and scheduling when asked how to improve his or her experience, for example—so leave several columns open in your spreadsheet to account for each one.

If you are surveying over multiple occasions, it is always a good idea to enter data as you collect it. You can even run interim reports to see where the results are headed.

2. The Final Frontier: Summary and Analysis

Making sense of a large number of surveys requires creating summary statistics that describe the dataset as a whole. Different types of questions lend themselves to different summaries. Multiple-choice questions are best summarized as *frequencies*, or the proportion (percentage) of people selecting each response. Scaled questions can be summarized by the *mean*—the mathematical average of all the responses—or by reporting the percentage of people who chose the most extreme responses. Popular and useful summary measures include "top box," which refers to the percentage of people who selected the highest response, such as *5* on a 1-to-5 scale; "top two box" is the percentage of people selecting the two highest responses, such as *6* or *7* on a 1-to-7 scale.

In some cases, you may want to *cross-tabulate* responses to see how two survey items interrelate. This is particularly true if you are interested in looking at differences between groups. At least one of the questions will require answers that can be placed into categories, such as a multiple-choice question. For example, if your survey asks respondents whether or not they are subscribers, you can cross-tabulate the data to compare the results of subscribers and nonsubscribers side by side. Most spreadsheet programs and online survey platforms have this capability.

When looking at differences between groups or over time, it's important not to focus on small variations. Instead, concentrate on *statistically significant* differences—that is, differences that are too large to occur by chance. These can be identified by running a *difference between proportions* test. A professional market research firm can run those tests, and several online tools exist if you prefer to do them on your own (although many of them assume some understanding of statistics, e.g., http://www.socscistatistics.com/tests/ztest/Default2.aspx).

MAKE RESEARCH A TEAM EFFORT

For audience research to have value, it needs to do more than deliver accurate information; it needs to be accepted and used by an organization. Involving key staff members at different points in the process can add value, build buy-in, generate interest, and raise organizational consciousness about what audiences are looking for and what their experience is. Don't wait until the research is done to share it. No one likes to be caught by surprise, and a research project is almost certain to meet resistance if it does not include the input of those who could be affected by it. It may also make sense, if resources permit, to hire a market research firm to design, conduct, and analyze the research. Outside professionals can lighten the workload and bring objectivity and valuable experience to a project.

Forming a Research Team

Typically, audience research is led by staff members in the marketing department, if an organization has one. (At smaller institutions, the executive director or another senior staff member might oversee the work.) That's because audience research is often seen as the province of marketing. While the head of marketing or education may lead a research project, getting to know an audience is *everyone's* business. Staff members from other departments should be informed and involved as stakeholders early on. As Linda Garrison, former director of marketing for Chicago's Steppenwolf Theatre Company explained when discussing her department's role in research and audience-building initiatives, "Marketing is the task leader, but artistic team members are full-blown participants."

Artistic directors in the most successful organizations receiving Wallace awards were curious about how audiences experienced their work, and therefore got involved in the research. They were not about to change their programming based on audience feedback, but they were determined to help visitors find a way into their work and to make newcomers feel welcome at their venues. Jeff Guido, the artistic director and gallery and shop manager for The Clay Studio, put it best: "How is your work meaningful if no one gets it?"

Discussing the research project with staff may reveal if your organization is currently making assumptions about the target audience. You might want to test some of those assumptions in your research. Pacific Northwest Ballet, for instance, thought that young people new to ballet would be drawn to more contemporary pieces. That assumption turned out to be false—from their research, and with the confirmation of box-office receipts, it learned that young newcomers prefer traditional ballet because the stories are familiar and therefore more accessible.

A research brief can make internal conversations leading up to research much more productive. It's a document that explains the audience-building challenge being addressed, the research objectives, the research plan, and how the results will inform decision making (see sidebar, *Parts of a Research Brief*). You don't need to have all the information up front to start writing the brief; it can be a living document that is updated and refined as you seek input from others in the organization and gain clarity on the research. Indeed, sharing the brief with others can lead to frank discussions about whether the organization is prepared to act on the results of the research. If the answer is no, you'll need to revise your objectives to focus on areas where the project can have the most impact.

Staff in other departments will likely approach the research from different vantage points and may have their own questions about pursuing a new audience. They may also have served the target audience at another organization and can share what they learned in that experience. Incorporating their feedback into the research objectives builds buy-in. As their own questions become integrated into the project, they'll become interested and feel invested in the outcome.

It's important, however, to resist asking everything that everyone might

▶ **PARTS OF A RESEARCH BRIEF**

■ Background
 • A statement describing the audience-building challenge
 • What is already known about the target audience
■ Research objectives
 • What questions about the target audience the research will answer
 • What artistic or auxiliary programming and/or marketing the research will inform
■ Research plan
 • Method: Which techniques will be used (e.g., focus groups, qualitative interviews, or surveys)
 • Research participants: Who will take part in the research
 • Questions: Outline of topic areas
 • Analysis plan: How the data will be analyzed
■ Results and implications: Which decisions the results will inform
■ Timeline: Deadline for the research results, as well as realistic dates for completing each component of the project

suggest. There's only so much you can ask in a focus group, and only so many questions most people are willing to answer on a survey. Project leaders should feel empowered to determine which research questions best meet organizational objectives.

Staff involvement should continue throughout a research project. Invite artistic staff and others to observe focus groups, for example, so they can hear what participants have to say firsthand. One organization got valuable feedback from focus groups on how to talk about its art form with newcomers. Unfortunately, its artistic leaders didn't go to the focus groups. Later, when the marketing department developed new communications materials based on these insights, the artistic staff quashed it. They weren't convinced that a new strategy was necessary because they hadn't heard the focus group participants themselves. Nothing the marketing department said or did could sway them.

TIP When refining your objectives, it's also rewarding to review the existing research about your target audience. There's no point in doing research that duplicates the work of others. Online resources such as PolicyMap (www.policymap.com) offer free access to U.S. census data that can detail, for instance, the demographics of a particular neighborhood you're targeting. Regional arts organizations, research groups such as the Pew Research Center, and service organizations such as the American Alliance of Museums, Opera America, and Theatre Communications Group may have conducted their own research on the tastes, preferences, and lifestyles of your target audience. They may even have examined the audience's perceptions of your art form. Peers at other arts organizations may be a source of information, as well. Such information can be extremely useful in generating your own hypotheses and offer insights that directly apply to your audience-building challenge.

The Value of an Outsider: Working with Professional Market Researchers

A focus group can look deceptively simple to conduct. It's just a conversation with a group of people around a table, right? In fact, getting the right people to the table, knowing which questions to ask and how to ask them, and managing the group dynamic as the discussion unfolds—all while accomplishing the research objectives—is often best left to an experienced moderator. A visitor survey can also benefit from the experience of a market research professional. They can help develop a sampling plan, phrase survey questions that are both clear and objective, and perform sophisticated data analyses that may be hard for an organization without in-house expertise to undertake.

There are certainly instances when an organization can manage a research project completely on its own. It's most feasible when the research questions are straightforward, such as visitor demographics or other basic facts that can be captured with a survey. In-depth interviews are possible, too, provided

the topics aren't too complex, nuanced, or politically charged. It helps if the staff has some research experience. The Isabella Stewart Gardner Museum took advantage of the research experience of one of its staff members to run a series of in-house brainstorming sessions that unearthed programming and marketing ideas for an event targeting young adults (see page 25, in Chapter 1). The San Francisco Girls Chorus and The Clay Studio took a hybrid approach, administering and printing their surveys themselves but contracting with research firms to help design the questionnaires and analyze the data (see pages 67 and 78, in Chapter 3).

But by and large, the organizations profiled in this guide that tapped the expertise of outside market researchers found that the partnership had several benefits that magnified the value and impact of their research:

Translating program objectives into research objectives. An experienced market researcher consults with an organization's staff to really understand what they want to accomplish with their audience-building initiative and how research will inform their strategy. He then develops research objectives based on those goals and determines the best methodology for accomplishing them, bringing to bear considerable experience and understanding of what questions are testable and how to best approach them. He will also create a research plan and focus group discussion guide.

Putting the results to work. Professional moderators think strategically and make the research actionable faster, says Ellen Walker, Pacific Northwest Ballet's executive director. Having seen multiple situations and research applications, they know how to take the raw data and spot the implications. "They synthesize what they hear—pulling out themes—and apply it to your work," she explains. "They prompt you to consider what you're going to do about it, how it will be reflected in diverse areas like messaging, pricing, and how the ushers are going to treat the audience."

Bringing a fresh (and unbiased) perspective. Professional moderators look at problems from multiple angles, in large part because of their years of experience and also because they're not rooted to your organization's ways of seeing things. "They think of questions that

you don't because you're inside it all the time," says Julie Crites, development officer for the Museum Council at the Museum of Fine Arts, Boston. They also approach the research without a vested interest in the outcome. "If I was going to pull together a focus group, I would probably ask some dumb questions," says Melanie Smith, executive director of the San Francisco Girls Chorus. "I'd frame the discussion in such a way to get the answer I *thought* I wanted, rather than the answer that *was*." Fleisher Art Memorial's director of programs, Magda Martinez, agrees, adding that an organization might not even recognize when its biases are coloring the research. "As an institution, you already have a lens when you're creating questions," she says. "Even though it's not your intention, you can ask a leading question that you think is objective."

That perspective carries through to how outside researchers synthesize information. Lani Willis, marketing director at the Minnesota Opera, notes that the independent moderator her staff worked with "didn't come with our biases or baggage" when listening to group discussions with first-time operagoers. The moderator saw connections that she and her staff might have missed because their way of promoting opera was so ingrained. The marketing that clicked with their current audience, however, wasn't necessarily the right approach with newcomers. The moderator helped Willis and her staff see that, in part because she was attuned to spotting patterns and also because she approached what she heard in the focus groups with an open mind. These are important assets to have on your side, especially when you're looking to engage a new audience.

Raising difficult subjects. An outside market researcher can broach issues that may be tricky to bring up internally. "A consultant can say the tough things that make you think," says Smith at SFGC. They encourage an organization to face the "hard realities" that might otherwise get sidelined, she adds. Walker at Pacific Northwest Ballet credits an outside moderator for helping her staff react objectively rather than emotionally when focus group participants new to ballet criticized the organization's advertising. Walker and her staff could have dismissed

the feedback—after all, they had created the ads. Instead, the consultant helped the staff keep the criticism in context. She pointed out that the ads hadn't necessarily been designed to appeal to newcomers. She also helped them see how the research identified ways to make the ballet company more accessible to the new audience it wanted to reach while still representing what it stood for.

Finding the Right Partner

Not all market researchers demonstrate the characteristics just described. Quality can vary, so it's important to consider several potential partners before selecting one. Peers at other organizations who've worked with a research provider may be able to offer recommendations. Ask them about the experience they had—it will be a good predictor of your own. WEA grantees also suggest these tips for finding a match:

1. Look for relevant experience. An outside researcher doesn't necessarily have to work in your discipline, but should understand the challenges facing the nonprofit arts. "You can't take focus groups about Gatorade and apply that to a ballet company because it's a different relationship," says PNB's Walker. "They need a sense of the common obstacles that we face as arts organizations in terms of getting people to participate, how people choose discretionary events, and how they prioritize different kinds of experiences. If a researcher has that sense, they can move the conversation quickly in a productive direction."

2. Hear them out. Most research providers are happy to discuss how they would approach a particular challenge. To get the most out of the conversation, you'll first need to explain what you want to find out with the research and how you'll use the results. A research brief, as described earlier in this chapter, can make the discussion more fruitful. Then, sit back and listen to their take on your problem. Do they seem to understand your organization and the audience-building challenge it faces? Are you both speaking the same language?

3. Review proposals carefully. You might end up asking more than one potential partner to submit a formal research proposal. It should include a budget, deadlines for various stages of the project, and information about members of the research team and their roles. Your main contact person should be noted, too. The proposal should explain, in plain English, the research project's objectives and methodology. Don't be impressed by a method that sounds sophisticated if you can't see clearly how the results will be applied to your initiative or help you make better decisions.

4. Consider chemistry. You'll be working with this consultant or firm for a long time. Be sure you like them! Make sure other key decision makers in your organization feel the same. "If you have a board involved, they have to like and trust them too, or they won't take anything they say seriously," notes Smith at SFGC.

The Power of Sharing

Sharing the results of your research once the data has been analyzed and the implications are clear can help foster an internal culture that's interested in the audience perspective. Be prepared for staff members to ask questions. Some may even challenge the findings, and that's okay—it's a sign that they are taking the research seriously.

Some organizations go as far as sharing their research findings with their board of directors to gain support for initiatives and even overcome some initial resistance. After Fleisher Art Memorial did research with underserved groups in its neighborhood to understand how to interest them in on-site programs, the staff members who led the project immediately presented the results to their colleagues and the board. The research clarified what the biggest barriers preventing people in the neighborhood from visiting Fleisher were and surfaced ways that the organization could overcome them. The target audience that had once seemed elusive now had a voice, and for many staff members, the research instilled a sense of human connection and immediacy.

It's important to keep a few things in mind when sharing research results. First, research is just one input used in making decisions. Many staff members will recognize this, but there may be some who feel the research suggests specific actions. Artistic and curatorial staff can be especially sensitive to this, but they are by no means alone. Staff members will more readily embrace research findings that seem to expand options, not limit them. While audience research can identify new ways to make your organization's work accessible, it will be rebuffed if it is presented as prescriptive.

One additional caution: Beware of cherry-picking. Don't present only select research findings, discount uncomfortable truths, or, worse, slant the results to fit a personal or departmental agenda. It is not only a waste of time and resources, but also always backfires and almost always gets discovered, especially when decisions are made based on "truths" that do not pan out.

For organizations committed to understanding and welcoming new audiences, research can lay the groundwork for collaboration across departments, particularly as staff members begin to see the results of their efforts—not just in box-office receipts, but also in the way the public interacts with them. Just ask Steppenwolf Theatre Company. Through focus groups, it learned that current audience members attended the theatre to challenge themselves and explore new ideas. That insight sparked an initiative, embraced by the entire organization, to get single-ticket buyers to the theatre more often. It included post-performance discussions with artists, online forums, and other opportunities for audience members to explore meaning in Steppenwolf productions. It worked: The number of single-ticket buyers who purchased tickets to more than one performance increased by 61 percent in three years, alongside subscriber retention gains.

The returns were not just financial for Steppenwolf. The initiative created a stronger connection between the artistic staff and the audience reacting to its work. And it nurtured a collaborative rapport across the organization because everyone shared the same objectives of wanting to better understand and engage the audience. "Marketing brings to the table all the research, while artistic brings what they see over the footlights and in post-show discussions,"

said Linda Garrison, Steppenwolf's marketing director at the time of the initiative. "There is a constant flow of, 'I heard this, I saw this.' Everyone is always thinking about who's in the theater seats. Everyone wants to contribute to improving that understanding of the audience."

RESEARCH MATERIALS

Chapter 1: Pacific Northwest Ballet

▼

1. Focus Group Screener – Teens

▼

2. Focus Group Screener – Young Adults

▼

3. Focus Group Discussion Guide

PACIFIC NORTHWEST BALLET FOCUS GROUP SCREENER – TEENS

Strategic Action, Inc. 140 West End Avenue, 9B New York, NY 10023 saikg@verizon.net

Teen's name: _____

Parent's name: _____

Street Address: _____

City/State/Zip _____

Daytime Phone #: _____ Evening Phone # _____

ASK TO SPEAK WITH PARENT FIRST – YOU <u>MUST</u> HAVE THEIR PERMISSION TO PROCEED.

Hello, I'm _____ calling on behalf of Strategic Action, Inc. a national marketing research firm. We're conducting marketing research on teens and the performing arts in Seattle. If you have a child in the appropriate age group, we'd like your permission to ask them a few questions. Then, if they qualify, we may invite them to attend a focus group, for which they would be paid a small stipend. Before I speak with your child, I'd like to ask you a few questions.

1. First, do you have any children living in your home, in the following age groups?

Under age 13 []	
13-15.. []	**IF NO CHILDREN 13-17, THANK AND**
16-17.. []	**TERMINATE.**
18 or older []	

1a. Do you, or does any relative or close friend work in any of the following? (READ LIST)

	No	Yes	
An advertising agency	[]	[]	
A marketing/marketing research firm	[]	[]	**IF YES TO ANY, THANK**
A public relations firm	[]	[]	**AND TERMINATE**
A cultural institution, such as a museum, theater, or dance company	[]	[]	

1b. Are you willing for us to speak with your child and, if he or she qualifies, for them to participate in a focus group?

Yes........................... [] **ASK TO SPEAK WITH TEENAGER**
No............................. [] THANK AND TERMINATE

INTRODUCE YOURSELF TO TEEN: Hello, I'm _____ calling on behalf of Strategic Action, Inc. a national marketing research firm. We're conducting marketing research on teens and the performing arts in Seattle. I'd like to ask you a few questions.

2a. First, have you attended any of the following types of performances or events in Seattle within the past six months? (READ LIST)

Professional live theater, at venues such as Seattle Rep or ACT......................[]
A museum, such as the Seattle Art Museum, Experience
 Music Project or Henry Art Gallery...[]
A rock concert..[]
Other live music, such as jazz, a classical concert, or opera...........................[]
Bumbershoot Festival ..[]
The Seattle Film Festival ...[]
Professional dance, such as Pacific Northwest Ballet
 or a performance at On The Boards...[]
A VERA Project show ..[]
A Sounders game ...[]

IF NONE MENTIONED, THANK AND TERMINATE

2b. Approximately how many times did you attend (READ TYPES MENTIONED IN Q2a)?

Professional live theater, at venues such as Seattle Rep or ACT.....................____
A museum, such as the Seattle Art Museum, Experience
 Music Project or Henry Art Gallery...____
A rock concert..____
Other live music, such as jazz, a classical concert, or opera...........................____
Bumbershoot Festival ..____
The Seattle Film Festival ...____
Professional dance, such as Pacific Northwest Ballet
 or a performance at On The Boards...____
A VERA Project show ..____
A Sounders game ...____

MUST HAVE ATTENDED AT LEAST TWO EVENTS DURING PAST SIX MONTHS – RECRUIT A MIX OF EVENT TYPES NO MORE THAN THREE PER GROUP MAY HAVE ONLY ATTENDED A SOUNDERS GAME

3a. Which of the following cultural organizations have you heard of? (READ LIST)
3b. Have you attended performances by (READ ALL HEARD OF IN Q3a) within the past year?

	Heard	Attended
ACT Theater	[]	[]
Bumbershoot Festival	[]	[]
Experience Music Project	[]	[]
Fifth Avenue Theater	[]	[]
Pacific Northwest Ballet	[]	[] SEE INSTRUCTIONS BELOW
Seattle Art Museum	[]	[]
Seattle Opera	[]	[]

▶ 123

FOR EACH PERFORMANCE TYPE <u>NOT</u> ATTENDED IN Q2A ASK:

4a. You mentioned that you have not been to (TYPE FROM Q2a) within the past six months. If you were invited by a friend or read an interesting description of a performance or exhibit, would you be extremely likely, very, somewhat, not very or not all likely to attend (TYPE FROM Q2a)?

	Extremely	Very	Somewhat	Not Very	Not at all
Professional live theater	[]	[]	[]	[]	[]
Museum	[]	[]	[]	[]	[]
Rock concert	[]	[]	[]	[]	[]
Other live music (jazz, concert)	[]	[]	[]	[]	[]
Film Festival	[]	[]	[]	[]	[]
Professional dance performance	[]	[]	[]	[]	[]
VERA Project show	[]	[]	[]	[]	[]
Sounders game	[]	[]	[]	[]	[]

5. What grade of school are you currently attending?

6. Please describe what contributes to making a live theater, music, dance performance or sports event memorable. Be as specific as you like.

PLEASE RECRUIT ONLY TEENS WHO ARE WILLING TO EXPRESS AN OPINION, DO NOT HAVE A HEAVY ACCENT AND EXPRESS THEMSELVES CLEARLY.

7. Record Gender: Female -------- [] Male -------- []

We are assembling a small group of teens to discuss cultural events in Seattle and we would like to include your opinions. The goal of this research is to hear about your experiences and interests and get your reactions to some things we are considering. Your (mother / father) has already agreed to your participation.

As a token of our appreciation for your participation we will give you a gift of $75. Would you like to participate?

⇒ Please ask them to bring reading glasses, if needed.
⇒ Provide time, location and directions
⇒ Ask them to arrive <u>at least</u> 10 minutes prior to the start of the group

PACIFIC NORTHWEST BALLET FOCUS GROUP SCREENER – YOUNG ADULTS

Strategic Action, Inc. 140 West End Avenue, 9B New York, NY 10023 saikg@verizon.net

Respondent's name: _____

Street Address: _____

City/State/Zip _____

Daytime Phone #: _____ Evening Phone #_____

(CHECK MALE/FEMALE STATUS: WOULD LIKE EQUAL NUMBERS IN EACH SESSION IF POSSIBLE)

Hello, I'm _____ calling on behalf of Strategic Action, Inc. a national marketing research firm. We're conducting marketing research on the performing arts in Seattle and we would appreciate your participation in our project.

1. First, do you, or does any relative or close friend work in any of the following?
 (READ LIST)

	No	Yes
An advertising agency	[]	[]
A marketing/marketing research firm	[]	[]
A public relations firm	[]	[]
A cultural institution, such as a museum, theater, or dance company	[]	[]

IF YES TO ANY, THANK AND TERMINATE

2. Because we are looking to fulfill certain demographic requirements, could you please tell me which of the following groups includes your age? (READ LIST)

Under age 13	[] THANK AND TERMINATE
13-17..	[] **GO TO TEEN SCREENER**
18-24..	[]
25-30..	[]
31-34..	[]
35 or older	[] → **FIND OUT IF THEY HAVE CHILDREN IN APPROPRIATE AGE GROUP: IF YES: ASK TO SPEAK WITH CHILD IF NO: THANK AND TERMINATE**

2a. Have you attended any of the following types of performances or events in Seattle within the past six months? (READ LIST)

Professional live theater, at venues such as Seattle Rep or ACT......................[]
A museum, such as the Seattle Art Museum, Experience
 Music Project or Henry Art Gallery...[]
A rock concert...[]
Other live music, such as jazz, a classical concert, or opera............................[]
Bumbershoot Festival ..[]
The Seattle Film Festival ...[]
Professional dance, such as Pacific Northwest Ballet
 or a performance at On The Boards..[]
A VERA Project show ...[]
A Sounders game ..[]

> **IF NONE MENTIONED, THANK AND TERMINATE**

2b. Approximately how many times did you attend (READ TYPES MENTIONED IN Q2a)?

Professional live theater, at venues such as Seattle Rep or ACT......................___
A museum, such as the Seattle Art Museum, Experience
 Music Project or Henry Art Gallery...___
A rock concert...___
Other live music, such as jazz, a classical concert, or opera............................___
Bumbershoot Festival ..___
The Seattle Film Festival ...___
Professional dance, such as Pacific Northwest Ballet
 or a performance at On The Boards..___
A VERA Project show ...___
A Sounders game ..___

> **MUST HAVE ATTENDED AT LEAST TWO EVENTS DURING PAST SIX MONTHS – RECRUIT A MIX OF EVENT TYPES**
> **NO MORE THAN THREE PER GROUP MAY HAVE ONLY ATTENDED A SOUNDERS GAME**

3a. Which of the following cultural organizations have you heard of? **(READ LIST)**
3b. Have you attended performances by **(READ ALL HEARD OF IN Q3a)** within the past year?

	Heard	Attended
ACT Theater	[]	[]
Bumbershoot Festival	[]	[]
Experience Music Project	[]	[]
Fifth Avenue Theater	[]	[]
Pacific Northwest Ballet	[]	[] **SEE INSTRUCTIONS BELOW**
Seattle Art Museum	[]	[]
Seattle Opera	[]	[]

FOR EACH PERFORMANCE TYPE NOT ATTENDED IN Q2A ASK:

4a. You mentioned that you have not been to (TYPE FROM Q2a) within the past six months. If you were invited by a friend or read an interesting description of a performance or exhibit, would you be extremely likely, very, somewhat, not very or not all likely to attend (TYPE FROM Q2a)?

	Extremely	Very	Somewhat	Not Very	Not at all
Professional live theater	[]	[]	[]	[]	[]
Museum	[]	[]	[]	[]	[]
Rock concert	[]	[]	[]	[]	[]
Other live music (jazz, concert)	[]	[]	[]	[]	[]
Film Festival	[]	[]	[]	[]	[]
Professional dance performance	[]	[]	[]	[]	[]
VERA Project show	[]	[]	[]	[]	[]
Sounders game	[]	[]	[]	[]	[]

**IF NOT VERY OR NOT AT ALL TO DANCE PERFORMANCE
THANK AND TERMINATE**

5a. When was the last performance for which you personally purchased the tickets?

Within past 3 months []
3 – 6 months ago []
More than 6 months ago [] SKIP TO Q6a

5b. Including your own, how many tickets did you purchase for that performance?

#_____ (IF FEWER THAN 4, SKIP TO Q6a)

5c. Who initially suggested attending that specific performance / event? (READ LIST)

You alone [] QUALIFIES AS A "LEADER"
Someone else []

6a. As a part of every survey we ask some general background questions so that we can make sure we have a good representation of the population. First, which of the following describes your marital status?

Married .. []
Single .. []
Separated/widowed/divorced []

6b. Do you have any children?

Yes... [] **CHECK QUOTAS**
No ... []

6c. Which of the following best describes the highest level of education you have achieved to date? (READ LIST)

Some high school []
High school graduate........................... []
Some college []
College graduate................................. []
Post grad work or degree..................... []

7. Please describe what contributes to making a live theater, music, dance performance or sports event memorable. Be as specific as you like.

PLEASE RECRUIT ONLY INDIVIDUALS WHO SPEAK WELL, DO NOT HAVE A HEAVY ACCENT AND EXPRESS THEMSELVES CLEARLY.

8. Record Gender: Female -------- [] Male -------- []

We are assembling a small group of people to discuss cultural events in Seattle and we would like to include your opinions. The goal of this research is to hear about your experiences and interests and get your reactions to some things we are considering.

We will not try to sell you anything. As a token of our appreciation for your participation we will give you a gift of $75. Would you like to participate?

⇒ Please ask them to bring reading glasses, if needed.
⇒ Provide time, location and directions
⇒ Ask them to arrive at least 10 minutes prior to the start of the group

SEE INSTRUCTIONS FOR COMPLETE DESCRIPTION OF THE QUALIFICATIONS FOR EACH GROUP.

PACIFIC NORTHWEST BALLET FOCUS GROUP DISCUSSION GUIDE

Strategic Action, Inc. 140 West End Avenue, 9B New York, NY 10023 saikg@verizon.net

Please note: These questions are intended as a starting point. They indicate the general flow of the discussion and the types of questions asked – not the specific order or wording. Also note that some question areas are repetitive – this is intentional. If one approach doesn't get at desired information, it will be asked again later in the discussion in a slightly different way. Timing will be adjusted based on participants.

Also note that throughout the first half of the session barriers and incentives for attending cultural events and dance specifically will be recorded on easel sheets – these will be used as a starting point for creating approaches / incentives for attracting new audiences.

I. INTRODUCTIONS (10 minutes)

Facilitator: Standard introduction including, purpose of discussion, reason for audio recording, confidentiality of individual responses, need for honesty and to speak about personal experiences/feelings.

Participants: Name, family composition, year in school / profession and…
- Briefly describe the live performances you attend:
 ⇒ Type – plays, concerts, dance, etc.
 ⇒ How often during the year?
 ⇒ Attend alone or with others/who? Who is the "leader?"

II. SELECTING EVENTS / INFORMATION SOURCES / BEHAVIORS (25 minutes)

- Think about the last performance you attended. How did you hear about it? Why did you decide to attend it? What interested you most about it? PROBE FOR SPECIFICS
 ⇒ Did you have any special deals / discounts?
 ⇒ Who did you go with?
 ⇒ How did you get there?
 ⇒ What did you do before / after the performance, i.e. did you have a meal? Drinks?
 ⇒ Describe the overall atmosphere of concert / venue / audience

- Thinking more broadly, if you hear or read about a performance, what gets you interested?
 ⇒ Why is that important to you?
 ⇒ What ultimately convinces you to buy / not to buy tickets?
 ⇒ How importance is price?
 ⇒ Do you specifically look for discounts / deals? If yes: Where?
 ⇒ If not mentioned: probe on importance of school connections for teens – is info / recommendations from teachers, notices on bulletin boards, friends, other? Why is that important?

- Within the past year or so have you attended any performances by a music, dance or dramatic group for the first time? Think specifically about something that was outside of your comfort zone – something that wasn't the kind of event or performance you'd usually consider going to.
 - ⇒ How did you hear about it? If someone told you, what specifically did they say?
 - ⇒ What got you interested in that specific performance?
 - ⇒ What concerns did you have?
 - ⇒ What was the deciding factor in choosing to attend?

- More generally, where do you get your information about cultural events, specific performances? (Probe for:)
 - ⇒ Web sites – which specifically? Why those sites?
 - o Ever gone to social networking web sites? Which?
 - o Ever gone to blogs? Which?
 - ⇒ Direct mail
 - ⇒ Mass media: Radio or TV advertising, newspaper or magazine ads or reviews
 - ⇒ Of all of these sources for information, which are most important to you? Why?

III. DANCE AND PNB IMPRESSIONS AND EXPERIENCES (15 minutes)

- I'd like to focus now on dance performances in Seattle. Tell me whatever you know about who, when and where, you might see a dance performance?

- What's your impression of dance performances? Describe atmosphere, audiences, cost – any other factors that describe dance performances.

- Have you heard of Pacific Northwest Ballet? If yes: Where have you heard about it?

- What's your impression of PNB?

- What might interest you in attending a PNB performance?

- Why wouldn't you be interested in attending one?

IV. IDEA GENERATION (40 minutes)

Our goal is to develop ways to bring more people to PNB. We believe there are ways to reduce some of the reasons why people choose not to come and / or to make coming more enticing. To get us started, I'd like you to think about what we've been discussing for the past hour and look at the lists of ways that you've mentioned that relate to why people come or don't come to performances and dance specifically.

First let's focus on some of the reasons why people don't go to performances / dance – can you add any reasons to the list of barriers we've already started? (WRITE ON EASEL)

Now, let's focus on some of the incentives you mentioned, some of the things that help to convince people to attend a performance. Can you add anything to that list? (WRITE ON EASEL)

- Now, what might PNB do to overcome the barriers? Think about ways to expand on some of the incentives or completely new ideas for convincing your friends to attend PNB. Don't worry if it isn't a perfect idea, or if it isn't completely formed – anything you mention might be the germ of a really great idea.

- Have each participant select one idea they especially like – something that they think would help them to convince others to attend the PNB.
 ⇒ Have group build on ideas – what would make them even better?

Reactions To PNB Ideas: Now I'd like you to distribute a brief description of some ideas that PNB is considering. Please take a few minutes to read through the list, but do not say anything. As you read through it please circle the three ideas that you find most compelling (DISTRIBUTE LIST)

- What did you like best on this list? Why?

- Was there anything surprising? Anything that you didn't expect? Describe.

- Was there anything you think you would find to be especially persuasive in attracting you? Your peers? Why?
 ⇒ Have group build on ideas – what would make them even better?

- If PNB were to introduce any of these ideas, what do you think the impact would be? Why? Would this change your opinion of them in any way? Describe.

V. COMMUNICATIONS (20 minutes)

- What are the best marketing materials you receive about events / performances?
 ⇒ Why are they the best? Are they motivating? In what ways?

- What is the best website you've seen from any arts organization?
 ⇒ Why is it the best? Is it motivating? In what ways?

I'd like you to look through some of Pacific Northwest Ballet's recent mailings and website pages. You may have already seen them. Please take a few minutes to read through them, but do not say anything. Feel free to write notes to yourself about things that you'd like to comment about. Also, please circle anything that you especially like, dislike or find confusing.

(AFTER THEY'VE HAD TIME TO LOOK MATERIALS OVER) Now, please write down the one or two things you like best about these and one or two things that you'd like to change. Review and discuss written comments.

- Overall reaction? What's the general impression you get of PNB from looking at these materials? Does that match your perception of them? Describe.

- Was there anything that surprised you either positively or negatively? Describe.

⇒ Does that change your opinion of PNB in any way? Describe.

- What would make you decide to attend one of these performances?
 ⇒ Probe on key factors – schedule, venue, program, cost?

- What other information would you like to know? Why is that important?

Please carefully look through the materials one more time. Are there any specific words or phrases or photos that really get your attention – either positively or negatively?

- Describe and discuss.

VI. WRAP-UP (10 minutes)

Please write down:

- Of all the ideas we've discussed, which one or two would be most helpful to you in deciding to attend PNB? Why? Would you really do this – why / why not?

- If you could improve on any one of the ideas we discussed, what would you do to make it even better? Include as many details as possible

WHILE PARTICIPANTS ARE WRITING RESPONSES – GO TO BACK ROOM FOR ANY ADDITIONAL QUESTIONS. UPON RETURN ASK:

- Review responses.
- Any suggestions you'd like to make to PNB?

Do you have any last comments or questions about anything that we've discussed this evening? Thank you very much for participating.

Chapter 1: Fleisher Art Memorial

▼

1. Tip Sheet for Fleisher's Community Organization Partners

▼

2. Focus Group Participation Form

▼

3. Focus Group Discussion Guide

FLEISHER

Tips and Notes
for recruiting participants for Fleisher Art Memorial group discussions

Below are some general tips and guidelines to consider when recruiting participants to the upcoming discussion groups April 10th and 11th.

- The "participant form" (one-sheet with general contact information) should be filled out—at least in part—for each participant. We will use these to keep track of how many participants we have in each group, and what their names are. We would love to have the list of participants the week before, if possible.

- Each group will contain 8-10 people—hopefully no less than 8, but no more than 10. (The type of group discussion we need to have is very difficult to lead with a large group.)

- So, participants should know that any friends or family members that they bring with them won't be able to participate in the discussion groups. If they do bring friends along, they'll be invited to participate in art-related activities that Fleisher is holding at the same time in a separate room. We'd like you to emphasize that only participants that you, the recruiter, have contacted and confirmed with directly should expect to join the discussion. (It can be difficult for us to manage the groups well when more people than we expect to participate show up.)

- Any kids, friends, or family members who come with a participant can join a Fleisher art activity for the 2-hour period. Activities will be appropriate for all ages.

- When recruiting, please try not to fill the slots with groups of family and/or friends. We'd like to have as many different perspectives and opinions represented as possible, so groups of people who have similar experiences won't be as helpful.

<u>As you know, your contact at Fleisher Art Memorial is:</u>
Joseph Gonzales *215-922-3456 x324* *jgonzales@fleisher.org*

<u>But please also feel free to contact us at Slover Linett Strategies.</u> We're Fleisher's research partner and will be working with Joseph to organize, manage, and lead the discussion groups.
Catherine Jett *773-348-9217* *catherine@sloverlinett.com*
Chloe Chittick Patton *773-348-9207* *chloe@sloverlinett.com*

Thank you in advance for your help!

FLEISHER

Fleisher Art Memorial
Group discussion participant form

<u>Note:</u> *Not all fields are required, but they would be appreciated. This information sheet will be used to keep track of participants for the upcoming discussion groups and to contact them as needed.* **This information will not be shared with any other organization.**

First name: _____

Last name or initial: _____

ZIP (required - circle one): 19147 OR 19148 _____

Address (optional): _____

Daytime phone number: _____

Evening phone number: _____

Email address (optional): _____
What ethnic or cultural group(s)
do you identify with most strongly? _____

What is your age? _____
Have you ever taken a class or seen
an exhibit at Fleisher Art Memorial? _____

What is your first language? _____
Are you comfortable communicating
in English? _____

This information will not be shared with any other organization.

	CONTACTS	
Fleisher Art Memorial Joseph Gonzales 215-922-3456 x324 jgonzales@fleisher.org		Slover Linett Strategies Catherine Jett 773-348-9217 catherine@sloverlinett.com

► **137**

Focus Group Discussion Guide

Primary goal: To provide insight and answer questions that will help FAM prioritize and gauge relative impact of the concepts it has generated.

Note: "FAM" is used throughout the guide as an abbreviation for Fleisher Art Memorial. The moderator will say "Fleisher."

Blue text refers to the community engagement strategies and concepts that are being referenced/tested in these discussions. Concepts underlined will be probed on explicitly.

Grey text refers to lower-priority questions that will be asked if there is time.

1. **Introductions (10 min)**

 - Interviewer role (independent researcher, guidelines, disclosures, audiotaping)
 - Welcome and thank you
 - Reinforce with respondents that their participation will be anonymous and personal information will not be shared with any agencies or individuals outside of the room.
 - Fleisher Art Memorial is a local community art school that teaches art classes to children, teens, and adults and presents art shows. It is holding this discussion because it wants to reach out and better serve the communities in its neighborhood and we'd love your input on some ideas it has to do so.
 - Any questions?
 - Roundtable introductions: name, what is your favorite thing to do in your free time?

2. **Art in Your Daily Life (15 min)**

 - Who here likes to make art or crafts or be creative in some way in their free time?
 - *Probe: when/where/what forms of creativity*
 - Have you ever taken an art class or made art with a group, whether formally or informally?
 - What kind of class or art making as a group? Do you do this regularly? Why/why not?
 - Do you ever see or make art at community events or gatherings? What types of art? What types of events?
 - Who organizes these events?
 - Where do you primarily see or do art in your life?
 - What kinds? Where?

138 ◀

> ▪ *Probe: In community/neighborhood or not?*

- How important is art or being creative to you, personally? Why?
- How important is art to your community or culture? Why?
- How important is it that your kids be creative? Why/why not?
 - ○ *Probe: if they don't have children, how about kids in the community?*
 - ○ Do you have any children or teenagers in your household that take art classes or make art in some way? Or grown children who took art classes growing up?

3. Awareness of FAM + FAM Marketing Materials (15 min)

- Who has heard of Fleisher Art Memorial before being invited to this discussion?
 - ○ Where did you hear about it?
 - ▪ *Probe: Have you ever heard about Fleisher in your neighborhood?*
 - ○ What have you heard?
 - ○ Does anyone know someone who has been there before?

Now I'm going to hand out Fleisher's course booklet [*Freehand*] and we'll spend a few minutes talking about it. Please take a few minutes to look through it by yourself, first.

- What are your first impressions of Fleisher from what you just saw?
 - ○ What kind of place does it seem like?
 - ○ Based on that booklet, what words would you use to describe <u>Fleisher</u>?
 - ▪ *Probe on initial impressions of FAM, not Freehand itself*
- What was the most interesting thing you saw when looking through?
- What was confusing or unappealing, if anything?
- Does the booklet tell you anything <u>new</u> about FAM that you hadn't heard before? What?
- Did you read any of the class descriptions? What were they like?
 - ○ *Probe: What kind of art is being offered? How interesting do the classes seem to you?*
- Turning to the registration form at the back, do you think this would be easy for you to use? What would make it easier?
 - ○ *Quick check: Would you find it easier or more difficult to register or pay for services online?*

- What questions do you still have about Fleisher after looking through this booklet?

4. Concepts with probes (60 min)

Language *[For Latino & Asian groups only]*

- Right now FAM only provides this course booklet and all of it's registration and advertising materials in English. Would that be difficult or frustrating for anyone to use or read this in English?
 o What language(s) do you typically use in your daily life?
- Are there any situations when it's difficult for you to use English or you prefer not to?
 o E.g. conversation, lecture/presentation, speaking, reading dense material, reading anything, writing, when others in the room are all native English speakers, on the phone, signing up for classes or programs, etc.
- *[If you wanted to take classes at Fleisher]* Which is the most important thing for you to read in your own language:
 o Registration form for classes
 ▪ *Translated class descriptions and registration materials*
 o Class names and descriptions
 o Signs around the FAM building
 ▪ *Building signs in multiple languages*
- When you call Fleisher, how comfortable would you be using an automatic phone greeting in English?
 o Speaking in English over the phone?
 ▪ *Email and voicemail in other languages*
- If you stopped by Fleisher in person, how comfortable would you be speaking to the reception staff in English?
 ▪ *Multilingual reception staff*
- During class...
 o How important would it be for there to be an instructor or translator there who speaks your native language?
 ▪ *Art courses in other languages*
 o Would an only-English art class be alright or would you not attend an English-only class? *(Probe)*
 ▪ *Translation services during classes*

- *In-house language support (V3) – ESL art courses*

Cultural specificity and types of art

Now I'd like you to imagine that you came to Fleisher to take a class. I'm going to ask you questions about what you'd want and expect to find with regards to FAM's building and people.

- Aside from language, in what ways could FAM make you feel welcome and comfortable if you came to take a class or see an exhibit? How so?
 - Who would you want to meet as staff/teachers?
 - What sort of other visitors would you want to see around FAM?
 - Culturally competent staff (V1)
- What creative or art-making traditions from your community do you think Fleisher could offer classes or workshops in?
 - What sorts of classes do you want to take that aren't being offered somewhere else?
 - Who would teach these classes?
 - Would they be ongoing classes that met once a week for a few weeks? Would they be one-day workshops? What would work best for your or your family's schedule?
 - What types of arts and crafts are your kids interested in that they can't take classes in somewhere else?
 - *Quick check to get yes/no/I don't know: Are your children or children in your neighborhood getting art classes in their school?*
 - *Class topics culturally relevant (A3) and culturally inspired (A10)*
 - *Class topics that relate to a specific heritage*
 - *Instructors who are experts and members of that culture*
 - *Types of art*
 - *Arte popular (A8)*
 - *Media and technical arts (A12)*
- If you were to take a class at Fleisher, who else would you want in the class?
 - *Probe: family, friends, other women, parents, kids, elders, people in your specific cultural community, etc.*
 - *Socially oriented or intergenerational group art making (A5)*

- If you yourself decided to take a class or workshop at Fleisher, what kind of practical concerns or questions would you have? *Probes:*
 - *Childcare available at Fleisher?*
 - *Transportation? Location/safety?*
 - *Cost?*
 - *Childcare while parents attend classes (A14)*
- The FAM gallery hosts shows with artwork by different artists. Sometimes the gallery will host a show that local community members put together.
 - What kind of art show would you want to help put together that would represent your community?
 - What kind of art would be in it?
 - Who would you want to help put it together? Which individuals, groups, or organizations?
 - *Community curated exhibitions (A6)*

Off-site outreach and delivery

Now think about what FAM could do *outside of its building* and in your community

- What could Fleisher do to connect to your community <u>in your local neighborhood</u>?
 - <u>Where</u> would Fleisher have to come to meet people in your community?
 - E.g. local restaurant, community center, school, church, etc.
 - What would you think if Fleisher worked with another local organization to host an event?
 - *Dinner & demo (M3)*
- What kind of event could Fleisher host in your neighborhood that would make you excited to go?
 - What type of event would you <u>not</u> want to go to?
- What if FAM had a location closer to where you live? What would you expect it to be like?
 - Would <u>you</u> visit it? Would you send <u>your children</u>? Why/why not?
 - *FAM South Satellite site (A7)*
- How else could FAM reach out into your community—or bring your community to FAM?
 - *Community night at FAM (A11)*
 - *Other orgs use FAM space to host their own cultural presentations*

 ○ *In-person representatives at community events (M2)*

Kids & families

- FAM offers some after-school and weekend classes for children and teenagers. How interested would you be in having your child/children attend a class?

 - *Note: Currently FAM classes are only offered to children 5 years old or older*

 - *Probe: Where? E.g. at Fleisher, at their school, somewhere else.*

- What kind of logistical concerns would you have, if any, if your children took a FAM class? *Probes:*

 - *Childcare before/after class?*

 - *Transportation/location?*

 - *Limits on distance and neighborhood safety?*

 - *Times of day?*

 - *Weekday or weekend classes?*

 - *Multiple siblings of different ages, including younger than five*

 - *Childcare before and after youth classes (A1, A4)*

 - *After school activities (A4)*

- Who would you trust to recommend a FAM class for your child?

 - *Probe on: School teacher, clergy, friend, etc.*

 - *You heard about Fleisher through an event at your kid's school or a teacher told you about FAM (A1)*

5. Closing (20 min)

- After talking and learning a little bit about FAM, how likely are you to seek out classes and activities to participate in?

 - What makes you want to go/not want to go?

 - *Probe: How about for your kids?*

 - *Probe – challenge respondents to not be too positive if it's not genuine*

- Who could recommend a Fleisher class to you that you would trust?

 - What could they say that would make you interested?

 - *Listen for: Members of your community had been to Fleisher and rec'd it to you (V2) or you met someone who is a student and Fleisher and s/he told you about it (V4),*

sloverlinett

- ○ Probe on: _Fleisher stories (M1)_
 - ▪ _For example, how appealing would someone telling a story about Fleisher serving immigrant communities be, even if you didn't know the person directly?_
- Where and how <u>should</u> Fleisher reach people in your community?
 - ○ _Community/language specific media and information outlets (M4)_
 - ▪ _Advertisements in target languages_
 - ▪ _Ads in local community--schools, community spaces, religious spaces_
- What else could Fleisher do to make you more interested in going to its classes or exhibitions?

Chapter 2: San Francisco Girls Chorus

▼

1. Focus Group Screener (Recruitment Questionnaire)

▼

2. Focus Group Discussion Guide

Martin & Stowe Recruitment Questionnaire San Francisco Girls Chorus

SFGC WILL PROVIDE LIST FOR RECRUITMENT, SOME LIST WILL BE FROM THIRD PARTY
ORGANIZATIONS, AND THE OWNER OF THE LIST MAY BE IDENTIFIED DURING RECRUITMENT.

ALL RESPONDENTS WILL MEET THE FOLLOWING SPECIFICATIONS:

- Current classical music patrons who have attended at least two classical music
 performances in the past year at venues in the San Francisco Bay Area

- All will be the decision maker with regard to attendance of these events

- None may have attended a San Francisco Girls Chorus event

 ⇒ Some may be aware of SFGC, but this is not required

- All will express openness to choral music (non-rejecters)

- All will have income of $75,000 plus (singles) or household income of $100,000 plus
 (married or living with partner) with a range of incomes represented

- A mix of genders (skewing female), ages 25–64, education (college grad or better),
 ethnicity and household types will be represented in each group

**All questions proceeded by this symbol ▶ are to be included on summary sheets.
Summary sheets are to be faxed or emailed to Martin & Stowe every day, thank you.**

Today's Date _____ Recruiter _____

Date of Appointment _____ **Time** _____ **am/pm**

Name _____ Home Ph. _____

Address _____ Work Ph. _____

_____ Email: _____

Hello, my name is _____ and I work for a market research firm. We are
calling on behalf of a local performing arts organization to understand how people select
between entertainment options. I'm not calling to sell you anything. My questions will only take
a few minutes of your time.

▶ RECORD GENDER Male () Female () SKEWING FEMALE

1. Do you or does any member of your household work in or have they ever worked in any of
 the following. **READ LIST.**

	YES	NO	
Advertising or public relations	()	()	TERMINATE ANYONE WHO RESPONDS "YES",
Marketing or market research	()	()	OTHERWISE CONTINUE WITH QUESTION 3
Newspaper or magazine	()	()	
In the arts	()	()	IF YES, CONTINUE WITH 2

2. Are you or is a member of your immediate family currently employed in the arts?

Yes	()	CONTINUE WITH 2B AND 2C
No	()	CONTINUE WITH 3

2B.) What is/was your (their) occupation in the arts? _____

2C.) When were you (they) employed in the arts? _____

RESPONDENTS OR THOSE WITH FAMILY EMPLOYED IN THE ARTS WILL REQUIRE CLIENT APPROVAL FOR QUALIFICATION.

3. When did you last participate in a market research group discussion or interview?

Never	()	**GO TO QUESTION 5**
Within the past 6 months	()	**CONTINUE**
More than 6 months ago	()	**CONTINUE**

4. What were the topics and approximate dates of these discussions?

TOPIC	DATE	TOPIC	DATE
_____	_____	_____	_____
_____	_____	_____	_____
_____	_____	_____	_____

IF THEY HAVE PARTICIPATED IN 2 OR MORE MARKET RESEARCH DISCUSSIONS IN THE PAST YEAR OR ON THE TOPIC OF PERFORMING ARTS, HOLD FOR CLIENT REVIEW. OTHERWISE CONTINUE.

5. ▶ Which, if any, of the following types of music do you listen to on a regular basis? Please consider all forms of listening such as broadcast radio, audio streaming or pre-recorded music. **READ LIST.**

Rock & Roll	()	
Folk and/or Country	()	
World	()	
Jazz	()	
Classical Music	()	**ALL MUST ANSWER THIS TO CONTINUE**

6. ▶ On a scale of 1 to 10, where <u>1 equals not at all important</u> and <u>10 equals extremely important</u>, how important are each of the following to you personally? Feel free to choose the number 1 or 10 or any number in between that best reflects your opinion.

How important is _____ to you?

a) Attending special exhibitions at art museums	1	2	3	4	5	6	7	8	9	10		
b) Attending live music	1	2	3	4	5	6	7	8	9	10		
c) Attending movie screenings	1	2	3	4	5	6	7	8	9	10		

ALL MUST ANSWER 7 OR ABOVE TO STATEMENT "B" TO CONTINUE.

7. Are there any of the following forms of entertainment that you would NOT attend?

8. ▶ Which, if any, of the following types of performances have you attended during the past year? Please include only performances by professional companies for which you purchased a ticket. READ LIST

9. ▶ FOR ANSWERS "D", "F", "G" AND "H", ASK: How many times in the past year did you attend?

		Q 7 NOT ATTEND	Q.8 ATTENDED	Q.9 # OF TIMES
a)	Ballet or modern dance		()	
b)	Broadway or musical theater		()	
c)	Plays or non-musical theater		()	
d)	**Chamber music concert**		()	
e)	**Classical music concert**		()	
f)	Jazz concert		()	
g)	**Opera**		()	
h)	**Choral or vocal ensemble performance**		()	
i)	Popular music in concert (rock, country, etc.)		()	
j)	World music or dance performance		()	

NONE WILL "NOT ATTEND" ANSWER "H" IN QUESTION 7. IF THEY WILL NOT ATTEND CHORAL MUSIC, TERMINATE.
ALL WILL HAVE ATTENDED PERFORMANCES OF ANSWERS "D", "E", 'G" AND /OR "H" AT LEAST TWICE IN THE PAST YEAR

10. ▶ Which of the following best describes your involvement in the decision to attend performances of classical and chamber music? READ LIST.

I am the sole decision-maker	()	CONTINUE
I am a co-decision maker	()	
I am somewhat involved in the decision	()	TERMINATE
I am not at all involved in the decision	()	

10. Are you familiar with any of the following arts organizations in the Bay Area? (READ LIST)

11. Have you attended any San Francisco performances of the following arts organizations in the past year? (READ LIST OF ORGANIZATIONS "FAMILIAR" WITH.)

	QUESTION 10 FAMILIAR	QUESTION 11 ATTENDED
American Bach Soloists	()	()
San Francisco Boys Chorus	()	()
San Francisco Chamber Orchestra	()	()
San Francisco Girls Chorus	()	()
San Francisco Opera	()	()
San Francisco Symphony	()	()
San Francisco Youth Orchestra	()	()

SOME MAY BE "FAMILIAR" WITH THE SAN FRANCISCO GIRLS CHORUS, BUT NONE WILL HAVE ATTENDED A SAN FRANCISCO GIRLS CHORUS EVENT.

Page 3

13. Are you or have you ever been a volunteer, a board member, a performer or student at any performing arts organization?

Yes () Which one? _____

No ()

14. Is any member of your family a volunteer, a board member or a performer or student at any performing arts organization?

Yes () Which one? _____

No ()

TERMINATE ANY ONE WHO ANSWERS SAN FRANCISCO GIRLS CHORUS TO QUESTIONS 13 AND 14.

15. ► Which of the following best describes your employment status?

Employed Full-time	()	**MOST WILL BE EMPLOYED AND MOST FULL-TIME**
Employed Part-time	()	
Student Full-time	()	**TERMINATE**
Student-Part-time	()	
Not employed / retired	()	**NO MORE THAN TWO**

16. ►How would you describe what you do? In other words, what is your occupation?

RECORD RESPONSE: _____

IF SOMEONE WHO IDENTIFIES THEMSELVES AS A "STAY-AT-HOME" SPOUSE, HOMEMAKER, ETC. SKIP TO QUESTION 18.

17. ► What is the name of the company or organization you are employed by?

RECORD RESPONSE: _____.

TERMINATE THE FOLLOWING: ADVERTISING, PUBLIC RELATIONS, MARKETING OR MARKET RESEARCH. RECRUIT A MIX OF OCCUPATIONS.

18. ► Which best describes your household status? **READ LIST**

Single adult **without** dependent children at home	()	
Single adult **with** dependent children at home	()	
Married or living with a partner **without** dependent children at home	()	**RECRUIT A MIX.**
Married or living with a partner **with** dependent children at home	()	

19. ► What is the highest level of education you have completed? **READ LIST.**

Some high school	()	
High school graduate	()	**TERMINATE**
Some college	()	
College graduate	()	**RECRUIT A MIX, BUT MOST WILL BE AT LEAST**
Post graduate	()	**"COLLEGE GRADUATES" OR BETTER**

Page 4

► **149**

20. ▶ I'm going to read you some age groups. We're not interested in your exact age, just your age group. Which of the following groups do you fit in? **READ LIST.**

Under 225	()	**TERMINATE**
25 to 34	()	
35 to 44	()	**RECRUIT A MIX**
45 to 54	()	
55 to 64	()	
65 plus	()	**TERMINATE**

21. ▶ As I read the following broad income categories, please tell me in which group your **[individual if single, household if married or living with a partner]** income falls into before taxes.
READ LIST. IF THE RESPONDENT REFUSES, CONTINUE TO NEXT QUESTION

Under $75,000	()	**TERMINATE.**
$75,000 to $99,999	()	
$100,000 to $199,000	()	**RECRUIT A MIX OF INCOMES IN EACH GROUP**
Over $200,000	()	

22. ▶ Which of the following best describes your ethnic heritage? **READ LIST.**

White/Caucasian	()	Asian/Pacific Islander	()
Hispanic Origin	()	Mixed Race	()
Black/African-American	()	Refused/Decline to Answer	()
Native American	()		()

23. Now we are going to switch gears for a minute and I would just like to ask you to briefly tell me about a movie or TV show you saw recently and why it interested you.

NOTE TO RECRUITER: RESPONDENT MUST BE ABLE TO EXPRESS HIS/HER THOUGHTS AND FEELINGS FREELY, IN DETAIL AND AT SOME LENGTH. IF RESPONDENT HAS SEEMED UNRESPONSIVE, IS HARD TO UNDERSTAND, HAS A POOR COMMAND OF ENGLISH OR A HEAVY ACCENT, DO NOT INVITE TO OUR GROUP.

INVITATION

On (<u>date</u>) _____ at (<u>time</u>) _____, we will be conducting a very interesting group discussion on behalf of a performing arts organization with people like yourself, and I would like to invite you to participate. The discussion will be about how people select between entertainment choices. You will get a chance to share your opinions with others like yourself, and we anticipate the discussion will be interesting and informative. You don't need to prepare for it in any way. No sales effort is involved; this is strictly a marketing research study to gain your opinion and those of others like yourself. It will take about TWO HOURS on _____(day), _____(date) at _____(time). At the end, you will be given $_____.

Can you make this session?
 () Yes RECORD NAME, ADDRESS, TELEPHONE NUMBER WITH APPOINTMENT DATE AND TIME AT THE TOP OF THE SCREENER.
 () No TERMINATE AND TALLY
 IF YES, SAY:
If you find you are unable to keep this appointment, please give us a call at _____ so that we may find a replacement for you. This is most important. Please do not send anyone to take your place. It would also facilitate your group discussion starting and *ending* on time if you could arrange to arrive **15 minutes before the discussion start time**. Thank you

SAN FRANCISCO GIRLS CHORUS QUALITATIVE RESEARCH
DISCUSSION GUIDE

OUR APPROACH

We recommend that the interview process be flexible in approach rather than follow a tightly structured question/answer format. This approach allows us to be responsive to the different dynamics and thought processes of each session and enables us to get beyond easy rational responses to discover more deeply felt and emotional reactions.

We recommend a discussion guide that allows time for probing issues that may arise in the course of the interview. So often, the richest insights come from exploration of new ground, areas of investigation that might not have been fully anticipated going in.

Finally, while thoughtful and sensitive questioning goes a long way in discovering what people feel, it is our firm conviction that it is not always enough. People are not always fully aware of what they really feel and, further, are often not able to fully express those emotions. For these reasons, we often use projective techniques that help people *access* and *express* what they feel.

As a result of this approach, this guide is not a script, but rather a road map to facilitate the flow of the discussion. The guide merely indicates areas of exploration, but the moderator will explore opportunities as they present themselves during the discussion. However, be confident that all areas of discussion will be probed fully.

I. INTRODUCTION/WARM-UP :10

Our objective here is to introduce the qualitative process to the respondents and give them a chance to get "warmed-up" and feeling comfortable. We will ask respondents to introduce themselves and tell us a bit about where they live, what they do, their families, etc. As background for the following discussion, we will also explore:

- *What types of performing arts do they enjoy? What organizations and/or venues do they attend? Do they subscribe to any performing arts organizations?*

II. SOURCES OF INFORMATION & DECISION MAKING :10

Our objective here is explore the sources of information respondents use to stay in touch with what's going on in the arts and to aid in their decision-making. We will do this by exploring the following issues:

- *In general, what sources of information do they use to stay in touch with what's going on?*
- *Are there additional sources that aid in their decision-making? Which are most useful and influential?*
- *In particular, how do they use new media and the Web with regard to the performing arts?*

III. CHORUSES AND CHORAL MUSIC :20

Our objective here is to explore respondents' experience with and perceptions of choral music and choral groups. At this point, we will not be revealing SFGC as the sponsor of the research or focusing on it. This exploration will be to understand motivations as well as barriers to attendance of choral events in general.

We will explore:

- *What comes to mind when they think of choral groups or choruses? What associations, thoughts, feelings, emotions?*

- *How do they feel about choral music? Is it a genre they are familiar with? Do they enjoy it?*

- *What choruses or choral groups are they aware of? Do they ever attend live performances?*

 ⇒ *Which choral groups have they seen in concert? What attracted them to attend these performances?*

 ◊ *What was the key thing that attracted them – the chorus itself, what they were performing, the venue, seasonality of the concert, etc.?*

 ⇒ *What has made some choral groups and/or particular choral performances they have attended more or less appealing than others?*

 ◊ *What in terms of the organization, venue, repertoire, choralography, guest artists, etc. contributes?*

 ⇒ *How do they feel about a performance focused on choral music versus choral music performed as part of a larger ensemble (e.g. an opera, dance or symphony)?*

IV. AWARENESS AND PERCEPTIONS OF SAN FRANCISCO GIRLS CHORUS :40

Our objective here is to explore the depth of awareness of SFGC and what image and perceptions exist based on actual knowledge of the organization and/or associations with its name and genre. A key part of this exploration will be understanding the potential appeal of as well as barriers to attendance of San Francisco Girls Chorus.

- *Are they aware of San Francisco Girls Chorus? Had they heard of it before today?*

 ⇒ *Have they ever attended a concert or event, which included the SFGC?*

- *What, if anything, do they know about SFGC?*

- *When they hear the name – whether they know the organization or not – what associations come to mind?*

We will use a guided visualization technique that will allow each person the opportunity to explore their own perceptions, rational and emotional, of the San Francisco Girls Chorus. Respondents will be asked to imagine that they are attending a SFGC performance and, as they are walked through the outlines of that experience, to notice not only what they are seeing and hearing, but what thoughts and feelings they are experiencing. We will then explore:

- *Was this an event they looked forward to attending or not? What were their expectations of what it would be like?*

- *Where did the performance take place? What venue?*

- *Who was in the audience? Who was not in the audience? What was the ambiance or atmosphere in the venue like?*

- *What was on the program?*

- *When the SFGC came on stage, what did they notice? Who/what else was on stage? What else did they notice?*

- *What was the performance like? Did they enjoy it?*

- *Was there an intermission? Did they mix and talk with other people? What was the conversation? Mood?*

- *Was this an experience they would seek out? Why or why not?*

If they are not addressed in the context of the above discussion, we will specifically probe to explore the following issues:

- *Beyond those discussed, what other barriers exist to attending a SFGC performance?*

- *What questions, if any, do they have about the SFGC? What would they need to know about SFGC to consider attending? What would make attending a SFGC performance more appealing to them? How do the following factor in?*

 ⇒ *Venue*

 ⇒ *Programming*

 ⇒ *Guest performers*

- *Do they know where the SFGC performs? How do they feel about the various types of venues used including churches?*

- *(If Chorissima comes up) What is Chorissima? How does it fit into the SFGC?*

- *With what other organizations would they group SFGC? How is the Girls Chorus similar to or different from these organizations? What makes them more or less appealing?*

As there may not be a depth of awareness about the actual organization, we will at this point share with respondents **a description of the SFGC** (and possibly performance schedule/venues) for them to react to. A copy of the description will be given to each respondent to read and make notes on. We will then discuss:

- *After reading the description, how did they come away feeling about SFGC?*

- *Based on what they read, would they feel more or less inclined to attend a performance of the SFGC? What made them more or less receptive?*

- *What did they find most compelling in this description? Least compelling?*

V. EXPLORATION OF ROUGH POSITIONING STATEMENTS :25

Our objective here is explore and understand reaction to 8-10 different positioning ideas for the San Francisco Girls Chorus (SFGC and SH Communications to provide). These will serve to provoke conversation and discussion around what might make SFGC most appealing to attend. In this regard, the statements shared should cover a range of potential ways to think about SFGC and will be as differentiated from each other as possible.

To respondents, these ideas will be identified as "messages" for the SFGC. Respondents will each be given a sheet listing all the messages and will be asked to circle for each, one of five "stick figures" (from one "embracing" SFGC to one "running away" from it). This will allow each respondent to clarify and commit to his or her initial and emotive response, prior to

discussion by the group. We will discuss the most and least positive ideas, starting with the most positive:

- *(Stick figures) How did the message leave respondents feeling about SFGC? What left them feeling that way?*

- *What did this message communicate to them? How would they sum it up in their own words?*

- *What, if anything, did the most appealing messages have in common? What did the least appealing messages have in common?*

- *In the end, what is most compelling to them about SFGC?*

VI. REACTION TO SFGC MARKETING MATERIALS AND HOME PAGE :15

As time permits, our objective here is to explore communication of and reaction to up to several SFGC materials, which may include its season brochure, advertising and/or home page. These stimuli will be exposed one at a time, in an order rotated by group. After viewing each, we will explore:

- *How did the piece leave them feeling about SFGC?*

- *What message did the piece communicate about SFGC?*

VII. CLOSURE

We will cover any final issues of interest and thank respondents for their participation.

San Francisco Girls Chorus

Founded in 1978, the San Francisco Girls Chorus has become a regional center for choral music education and performance for girls and young women ages 7-18. More than 300 singers from 160 schools in 44 Bay Area cities participate in this internationally recognized program, deemed "a model in the country for training girls' voices" by the California Arts Council.

The organization is comprised of five choruses: Chorissima, the concert, recording, and touring ensemble, conducted by Artistic Director Susan McMane; and the four-level Chorus School training program, supervised by Director Elizabeth Avakian.

Each year, the dedicated young artists of Chorissima present season concerts, tour nationally or internationally, and appear with respected sponsoring organizations, including San Francisco Symphony and San Francisco Opera. The Chorus has been honored to sing at many prestigious national and international venues, including the World Choral Symposium in Kyoto, Japan, in 2005. In March 2006, Chorissima was featured at the American Choral Directors Association Western Division Convention in Salt Lake City. In July 2007, Chorissima represented North America in the prestigious World Vision Children's Choir Festival in Seoul, Korea, and in the Gateway to Music Festival at the Forbidden City Concert Hall in Beijing.

Known as a leader in its field, the San Francisco Girls Chorus was honored in 2001 as the first youth chorus to win the prestigious Margaret Hillis Award given annually by Chorus America to a chorus that demonstrates artistic excellence, a strong organizational structure, and a commitment to education. Other awards include two ASCAP awards for Adventurous Programming in 2001 and 2004.

The Chorus School offers a program of unparalleled excellence, designed to take young girls from their first introduction to the art of choral singing through a full course of choral/vocal instruction. The comprehensive music education includes the study and development of choral artistry, vocal technique, music theory, music history, and performing style. The graduated curriculum is divided into four levels of achievement, carefully designed to increase technical skills, stamina, and discipline in accordance with the chorister's age and physical development. The discipline, teamwork, and concentration young girls learn in the Chorus School rehearsals and performances instill in them the values necessary for high achievement in music and in life.

The Chorus' discography continues to grow. In November 2006, Chorissima released a new CD entitled *Voices of Hope and Peace*, a recording that includes many exciting SFGC commissions. Other recordings include: *Christmas*, featuring diverse holiday selections; *Crossroads*, a collection of world folk music; and *Music from the Venetian Ospedali*, a disc of Italian Baroque music of which the *New Yorker* described the Chorus as "tremendously accomplished." The Chorus can also be heard on several San Francisco Symphony recordings, including three GRAMMY® Award -winners.

How does each of these statements leave you feeling about the San Francisco Girls Chorus?

. . . delivers to music lovers a rich exploration of the choral repertoire from classically-based choral works to folk songs to contemporary fare
. . . is an innovator in the creation and performance of new music to showcase the young female voice
. . . delights music lovers with fresh interpretation of musical masterworks
. . . performs with accomplished guest artists to deliver rich and satisfying performances that feature solo and choral voices.
. . . is the San Francisco Bay Area's premier young female choral ensemble
. . .provides classical music lovers with a deep and rich exploration of the classical vocal repertoire
. . . is recognized for its musical excellence though its national and international tours, its participation in world-class competitions and its expanding discography.
. . .excites music lovers with its spirited performances of choral music and professionally choreographed movements.
. . . engages its audiences with the rare combination of youthful voices performing at a near professional level.
. . . inspires audiences with its uplifting performances.

Chapter 2: Minnesota Opera

▼

1. Focus Group Screener (Recruitment Questionnaire)

▼

2. Focus Group Discussion Guide

MN OPERA WILL PROVIDE LIST FOR RECRUITMENT AND WILL BE IDENTIFIED DURING
RECRUITMENT AS THE SPONSOR OF THE RESEARCH

All respondents will be recruited from list provided by the Minnesota Opera. (Note: All
on the list responded to an offer of free tickets to attend the Minnesota Opera earlier this year
through 107.1 FM or were a member of the audience for a taping of Twin Cities Live for
KSTP-TV.)

▪ Two groups of people who had never attended opera prior to this event.

▪ Two groups of people who had attended opera prior to this event.

All questions proceeded by this symbol ▶ are to be included on summary sheets.
Summary sheets are to be faxed or emailed to Martin & Stowe every day, thank you.

Today's Date _____ Recruiter _____

Date of Appointment _____ **Time** _____am/pm

Name _____ Home Ph. _____

Address _____ Work Ph. _____

_____ Email: _____

Hello, my name is _____ and I work for a market research firm. We are
calling on behalf of The Minnesota Opera to ask people about their use of free tickets to attend
The Minnesota Opera. I'm not calling to sell you anything. My questions will only take a few
minutes of your time.

▶ **RECORD GENDER** Male () Female () **MOST WILL BE FEMALE**

1. Did you receive free tickets to The Minnesota Opera through either of these? **READ**
LIST.

The Ian & Margery show on 107.1 FM () **CONTINUE**

As a result of being an audience member of a taping of () **GO TO QUESTION 8**
the show, Twin Cities Live, on KSTP-TV

2. Did you use the ticket to attend a performance of the Minnesota Opera?

Yes () **CONTINUE**
No () **CONTINUE**

3. ▶Besides yourself, did anyone else use these tickets to attend?

Yes	()	**CONTINUE**
No	()	**IF THE RESPONDENT ANSWERED "YES" IN QUESTION 2, CONTINUE WITH QUESTION 6** **IF THE RESPONDENT ANSWERED "NO" IN QUESTION 2 THEN TERMINATE**

Page 1

4. ►Does anyone who attended with you live outside your household?

Yes	()	CONTINUE
No	()	GO TO QUESTION 6

IT IS NOT PERMISSIBLE TO HAVE TWO MEMBERS OF THE SAME HOUSEHOLD PARTICIPATE IN THIS STUDY.

5. ►Do you think they might be interested in participating in this market research project?

		RECORD CONTACT INFORMATION HERE AND THEN CONTINUE:
Yes	()	NAME _____ TELEPHONE _____ NAME _____ TELEPHONE _____
No	()	CONTINUE

6. ► I'm going to read you some age groups. We're not interested in your exact age, just your age group. Which of the following groups do you fit in? **READ LIST.**

Under 25	()	TERMINATE
25 to 29	()	
30 to 34	()	
35 to 39	()	
40 to 44	()	
45 to 49	()	MOST SHOULD BE BETWEEN 35 AND 59
50 to 54	()	
55 to 59	()	
60 to 64	()	
65 plus	()	TERMINATE

7. Are you a volunteer, staff or board member at The Minnesota Opera?

Yes () **TERMINATE**
No () **CONTINUE**

8. Are you a volunteer or employee at 107.1FM or KSTP-TV?

Yes () **TERMINATE**
No () **CONTINUE**

9. Do you or does any member of your household work in or have they ever worked in any of the following? **READ LIST.**

	YES	NO	
Advertising or public relations	()	()	TERMINATE ANYONE WHO RESPONDS "YES", OTHERWISE CONTINUE WITH QUESTION 11
Marketing or market research	()	()	
Television or Radio	()	()	
Newspaper or magazine	()	()	
In the arts	()	()	IF YES, CONTINUE

10. Are you or a member of your immediate family currently employed in the arts?

Yes	()	**CONTINUE WITH 10B AND 10C**
No	()	**CONTINUE WITH 11**

 10B.) What is/was your/their occupation in the _____
arts?

 10C.) When were you/they employed in the arts? _____

RESPONDENTS OR THOSE WITH FAMILY EMPLOYED IN THE ARTS WILL REQUIRE CLIENT APPROVAL FOR QUALIFICATION.

11. ▶ Prior to attending this performance of The Minnesota Opera, have you ever attended an opera performance?

Yes	()	**CHECK QUOTA FOR ATTEND GROUP AND CONTINUE**
No	()	**CHECK QUOTA FOR NON-ATTEND GROUP AND CONTINUE WITH QUESTION 13**

12. Prior to this performance of Minnesota Opera, about how many opera performances have you ever attended?

1	()	
2-3	()	
4-5	()	**CONTINUE**
6-10	()	
More than 10	()	

13. Since attending this performance of the Minnesota Opera, have you purchased tickets or a subscription to the Minnesota Opera?

 Yes () **CONTINUE**
 No () **GO TO QUESTION 15**

14. ▶ Which of the following best describes your involvement in the decision to purchase tickets or subscribe to The Minnesota Opera? **READ LIST.**

I was the sole decision-maker	()	
I was a co-decision-maker	()	**CONTINUE**
I was somewhat involved in the decision	()	
I was not at all involved in the decision	()	

15. ▶ Which of the following best describes your employment status?

Employed Full-time	()	**CONTINUE**
Employed Part-time	()	
Student	()	**CONTINUE WITH QUESTION 18**
Not employed outside the home	()	
Retired	()	

16. ►How would you describe what you do? In other words, what is your occupation?

RECORD RESPONSE: _____

17. ► What is the name of the company or organization you are employed by?

RECORD RESPONSE: _____.

TERMINATE THE FOLLOWING: TELEVISION, RADIO, ADVERTISING, PUBLIC RELATIONS, MARKETING OR MARKET RESEARCH. RECRUIT A MIX OF OCCUPATIONS.

18. ► What is the highest level of education you have completed? **READ LIST.**

Some high school	()
High school graduate	()
Some college	()
College graduate	()
Post graduate	()

19. ► As I read the following broad income categories, please tell me in which group your household income falls into before taxes. **READ LIST.**

Under $25,000	()	
$25,000 to $49,999	()	
$50,000 to $74,999	()	**IF THE RESPONDENT REFUSES, CONTINUE**
$75,000 to $99,999	()	**TO NEXT QUESTION**
$100,000 to $199,000	()	
Over $200,000	()	

20. Now we are going to switch gears for a minute and I would just like to ask you to briefly tell me about a movie or TV show you saw recently and why it interested you.

NOTE TO RECRUITER: RESPONDENT MUST BE ABLE TO EXPRESS HIS/HER THOUGHTS AND FEELINGS FREELY, IN DETAIL AND AT SOME LENGTH. IF RESPONDENT HAS SEEMED UNRESPONSIVE, IS HARD TO UNDERSTAND, HAS A POOR COMMAND OF ENGLISH OR A HEAVY ACCENT, DO NOT INVITE TO OUR GROUP.

INVITATION

On (<u>date</u>) _____ at (<u>time</u>) _____, we will be conducting a very interesting group discussion on behalf of the Minnesota Opera with people like yourself who attended the opera with these special tickets *and I would like to invite you to participate.* The discussion will be about what people thought about the performance they saw and opera in general.

You will get a chance to share your opinions with others like yourself, and we anticipate the discussion will be interesting and informative. *You don't need to prepare for it in any way.*

No sales effort is involved; this is strictly a marketing research study to gain your opinion and those of others like yourself. It will take about TWO HOURS on _____(day), _____(date) at _____(time). At the end, you will be given $_____.

Can you make this session?

() Yes RECORD NAME, ADDRESS, TELEPHONE NUMBER WITH APPOINTMENT DATE AND TIME AT THE TOP OF THE SCREENER.

() No TERMINATE AND TALLY

IF YES, SAY:

If you find you are unable to keep this appointment, please give us a call at _____ so that we may find a replacement for you. This is most important. Please do not send anyone to take your place. It would also facilitate your group discussion starting and *ending* on time if you could arrange to arrive **15 minutes before the discussion start time**. Thank you

THE MINNESOTA OPERA QUALITATIVE RESEARCH
DISCUSSION GUIDE

OUR APPROACH

We recommend that the interview process be flexible in approach rather than follow a tightly structured question/answer format. This approach allows us to be responsive to the different dynamics and thought processes of each session and enables us to get beyond easy rational responses to discover more deeply felt and emotional reactions.

We recommend a discussion guide that allows time for probing issues that may arise in the course of the interview. So often, the richest insights come from exploration of new ground, areas of investigation that might not have been fully anticipated going in.

Finally, while thoughtful and sensitive questioning goes a long way in discovering what people feel, it is our firm conviction that it is not always enough. People are not always fully aware of what they really feel and, further, are often not able to fully express those emotions. For these reasons, we often use projective techniques that help people *access* and *express* what they feel.

As a result of this approach, this guide is not a script, but rather a road map to facilitate the flow of the discussion. The guide merely indicates areas of exploration, but the moderator will explore opportunities as they present themselves during the discussion. However, be confident that all areas of discussion will be probed fully.

I. INTRODUCTION/WARM-UP :15

Our objective here is to introduce the qualitative process to the respondents and give them a chance to get "warmed-up" and feeling comfortable. We will ask respondents to introduce themselves and tell us a bit about where they live, what they do, their families, etc.

- *What types of entertainment do they enjoy, both on their own and (as relevant) with the family? What are key factors for them in selecting entertainment?*

II. HEARING ABOUT AND RESPONDING TO THE MINNESOTA OPERA OFFER :25

Our objective here is to explore how respondents first heard about the offer of comp tickets to attend The Minnesota Opera, what they felt about the offer and what compelled them to participate. We will explore the following:

- *How did they hear about the complementary tickets to The Minnesota Opera (i.e. Ian & Margery show on 107.1 FM, being an audience member at taping of Twin Cities Live at station KSTP, through a friend)?*

 ⇒ *Do they regularly listen to or watch these shows?*

 ⇒ *What is so appealing about these shows?*

- *What was their initial reaction to the offer of free tickets to the opera? What went through their minds?*

 ⇒ *What made the offer attractive? What were the key motivators or drivers to attend?*

 ⇒ *What else made the offer appealing? What, if anything, made it unappealing?*

⇒ *(If they were on the fence) What made them decide to accept or pursue getting tickets? Was it a decision they made on their own or did it involve another person?*

■ *Had they had any previous exposure to opera or was this their first time?*

⇒ *What were their feelings about opera prior to this?*

⇒ *In what ways had they been exposed to or experienced opera? Had they ever attended a live opera?*

■ *As the night of the performance approached, how did they feel about attending?*

⇒ *Were they looking forward to it or not? What were their expectations?*

III. THE EXPERIENCE OF ATTENDING THE MINNESOTA OPERA :30

Our objective here is to explore the actual experience of attending The Minnesota Opera and what contributed to or detracted from the experience. We will use a guided visualization technique to aid respondents in recalling their experience. Respondents will close their eyes and the moderator will walk them through their evening, including any activities or events prior to or after the performance. We will then discuss:

■ *How would they describe the experience of attending The Minnesota Opera?*

⇒ *What contributed to or detracted from their experience?*

⇒ *What was the evening like? Did they do anything before the performance? Attend the pre-opera lecture (with Ian)?*

⇒ *What opera did they attend? What was their reaction to the opera performance?*

⇒ *What did they do at intermission(s)?*

⇒ *Did they stay for the whole opera or leave early?*

⇒ *What did they do afterwards, if anything?*

■ *Was the experience what they anticipated it to be like or not? What surprised them in a positive (or less than positive) way?*

⇒ *What might have made their experience more satisfying, entertaining, rewarding?*

■ *Did attending the performance change their feelings about opera in any way? What in the experience made them more or less receptive to opera?*

⇒ *What, if anything, might have further enhanced the experience for the first time operagoer? Any operagoer?*

■ *Have they attended The Minnesota Opera since?*

⇒ *(If so) What compelled them to return? Was the experience any more or less satisfying?*

⇒ *(If not) Have they considered it? Would they buy a ticket and attend again? Under what circumstances would they think about attending again?*

⇒ *What would cause them to consider and/or make it more it more appealing to attend again? What, if anything, could The Minnesota Opera do to aid this process?*

IV. MARKETING MATERIALS AND IDEAS :45

Our objective here is to explore and understand reaction to a number of current marketing materials and ideas. As time permits, we will explore the communication of and reaction to commercials, brochures, web site home page, Lori & Julia concept and some concepts/terminology around ways to purchase tickets.

Respondents will be shown Minnesota Opera **commercials and brochures**, one at a time. Immediately after viewing, they will be asked to circle one of five "stick figures" (from one "embracing" The Minnesota Opera to one "running away" from it). This will allow each respondent to clarify and commit to his or her initial and emotive response, prior to discussion by the group.

- *(Stick figures) How did this commercial or brochure leave them feeling about The Minnesota Opera? What left them feeling this way?*

- *What did it communicate to them? What message did it convey?*

- *What, if anything, was particularly positive in the commercial or brochure? What, if anything, detracted from it?*

Respondents will then each be given a copy of the **"Lori & Julia" concept**. After circling the stick figure that best captures their reaction, we will discuss:

- *(Stick figures) How did they feel about this idea? Was it appealing or not?*

- *What might enhance it or make it more appealing?*

- *Are there other things that come to mind that would make it more appealing to attend The Minnesota Opera or to enhance their participation with it?*

 ⇒ *What might make the pre/intermission/post experience more enjoyable for them?*

Respondents will then each be given their own copy of The Minnesota Opera **web site home page** (also shown on screen). We will discuss:

- *What does the home page communicate to them about Minnesota Opera? What image of the Opera and/or feelings about the Opera does it leave them with?*

- *Is it a site they feel they would want to explore further? What encourages further exploration or not? What is their sense of what they could do or see at the site?*

- *What have they visited (or would they envision visiting) the site for? Was it (or is it) obvious where they would click to accomplish that?*

Also, if it has not already been explored above, we will want to delve into how respondents perceive **subscription, single ticket buying and packages** in terms of their desirability and especially with regard to flexibility as well as how they pay for them.

- *How do they prefer to buy tickets – as single tickets, packages, subscriptions? What do they prefer about purchasing this way?*

 ⇒ *What are the key drivers as well as deterrents to purchasing packages or subscriptions?*

- *Which offers the most/least flexibility – single tickets, subscription or packages?*
- *Would it be more attractive to be able to pay for a subscription or package over time?*
 - ⇒ *What would be the best way to refer to this type of payment program (e.g. layaway, 1/3 down, etc.)*
- *Which is more stimulating in terms of purchasing – seeing % off or actual price?*

V. CLOSURE :05

We will cover any final issues of interest and thank respondents for their participation.

Chapter 3: The Isabella Stewart Gardner Museum

▼

Gardner After Hours **Exit Survey**

Exit Survey

How did you hear about tonight's program?
(Please check all that apply)

☐ *After Hours* poster

☐ *After Hours* text message

☐ Email from museum

☐ Facebook / Yelp / Going (circle one)

☐ Museum's website

☐ Other websites: _____

☐ Newspaper/Magazine

☐ Someone I know told me about it

☐ While visiting the museum

How likely would you be to recommend *After Hours* to a friend or colleague? (Please check one)

☐ Extremely likely to recommend

☐ Somewhat likely to recommend

☐ Neither likely nor unlikely to recommend

☐ Somewhat unlikely to recommend

☐ Extremely unlikely to recommend

What made you say you would either recommend or not recommend *After Hours*?

How did you spend your time here?
(Please check all that apply)

☐ Explored the galleries

☐ Visited the special exhibition "Modeling Devotion: Terracotta Sculpture of the Italian Renaissance"

☐ Attended the *Avant Gardner* concert in the Tapestry Room

☐ Played the "Night / Day" gallery game

☐ Participated in a *Viewfinder* gallery talk

☐ Visited the courtyard bar

☐ Ate in the Gardner Café

☐ Sketched in the galleries

What did you enjoy the most?
(Please circle items listed above)

Have you been to the Gardner Museum before?
☐ Yes ☐ No

Have you been to *After Hours* before?
☐ Yes ☐ No

Please tell us about yourself:

Gender ☐ Male ☐ Female ☐ Do not identify

Age ☐ 18-20 ☐ 21-24 ☐ 25-34

 ☐ 35-44 ☐ 45-54 ☐ 55- 64

 ☐ 65+

If you are a student, what college/university do you attend?

Ethnicity

☐ African American/Black

☐ Asian/Pacific Islander

☐ Hispanic/Latino

☐ Mixed Ethnicity _____

☐ Other_____

☐ White/Caucasian

Who are you visiting with tonight?

☐ I came on my own

☐ I'm here with friends (# of people in group, including yourself) _____

☐ Other _____

Are you a member of the museum?

☐ Yes (individual/dual member) ☐ No

☐ Yes (your college/university is a member)

Join the *After Hours* list:

Name:

Email:

Cell (to receive text alerts and deals):

Mailing Address:

Chapter 3: The Clay Studio

▼

Clay Studio Visitor Survey

The Clay Studio Wants Your Opinion!

First, thank you so much for visiting The Clay Studio. So that we can continue to provide a top quality experience, we want to hear your opinions. Even if you loved it, we want to know what we can do better next time. The information you provide will also help us to obtain funding to continue our work. All of your answers will be kept strictly confidential and no one will contact you to sell you anything as a result of filling out this survey.

1. First, overall, how would you rate your visit today in terms of how much you enjoyed it personally? *(CHECK ONE ANSWER BELOW.)*

 Excellent .. ☐
 Very good... ☐
 Good .. ☐
 Fair... ☐
 Poor ... ☐

2. What, if anything, did you particularly like or dislike about The Clay Studio? *(PLEASE BE AS SPECIFIC AS POSSIBLE)*

 Likes:

 Dislikes:

3. How many times, excluding your visit today, have you been to The Clay Studio? *(CHECK ONE ANSWER BELOW.)*

 Never visited before, this is my first time ☐
 Once .. ☐
 Twice.. ☐
 Three times .. ☐
 Four times .. ☐
 Five or more... ☐

4. In which of the following ways did you hear about The Clay Studio? *(CHECK ALL THAT APPLY.)*

 Passed by and saw the gallery / shop ☐
 Internet search .. ☐
 Print advertising .. ☐
 Radio advertising ... ☐
 Newspaper reviews or feature stories.................... ☐
 Direct mailings .. ☐
 Word of mouth ... ☐

5. Based on your experience today, how likely are you to recommend The Clay Studio to your friends, relatives, or co-workers? *(CHECK ONE ANSWER BELOW.)*

 Extremely likely ... ☐
 Very likely.. ☐
 Somewhat likely ... ☐
 Not very likely.. ☐
 Not at all likely... ☐

(PLEASE TURN OVER FOR A FEW MORE QUESTIONS.) ➔ ➔ ➔ ➔ ➔

1

6. Which of the following have you visited or participated in within the past six months? *(CHECK ALL THAT APPLY.)*

First Friday in Old City ☐ Avenue of the arts ☐
Local galleries/art museums...... ☐ Art classes or workshops.................... ☐
Movies at the Ritz ☐ Live theater ... ☐
Live music ☐

Finally, a few questions for classification purposes only.

6. Are you a Clay Studio member?

Yes................................ ☐
No ☐

7. What is your zip code?

8. Are you currently a student at a 2 or 4 year college or university?

Yes...................... ☐
No ☐

9. With whom did you visit The Clay Studio today? *(CHECK ALL THAT APPLY.)*

Came alone.................................. ☐
Spouse... ☐
Child/children ☐
Friend(s)...................................... ☐
Others .. ☐

10. Which of the following categories includes your age?

Under 18 ☐
18-24.. ☐
25-34.. ☐
35-44.. ☐
45-54.. ☐
55-64.. ☐
65 or older................................... ☐

11. Do you have children **under 18** living at home?

Yes.............. ☐ ➔ Ages? _____
No ☐

12. Are you.....?

Male .. ☐
Female... ☐

Thank you so much for filling out this survey. Your feedback will help us design programs that better meet your needs. Please return your completed survey to the front desk or fax or mail it back to us at the fax number or address below.

The Clay Studio
137-139 North Second Street
Philadelphia, PA 19106
FAX: 215-925-7774

If you'd like to be added to our mailing list, please provide the following information:

Name:
Address:

Email:

2

▶ 173

QUALITATIVE RESEARCH TO EVALUATE AUDIENCE-BUILDING INITIATIVES

While a survey can give you an objective accounting of a new audience, tell you who is doing what, and reveal how much they enjoy the experience, it may not convey *why* things are clicking with them or not. Qualitative research can explore a newcomer's experience in detail and provide a more nuanced understanding of their interaction with your organization. Hearing people describe their visit in their own words can help you pinpoint what is and what isn't working with your audience-building initiative. It can examine visitors' overall enjoyment, their most and least favorite aspects of the programming, their comfort level (remember, they are new!), and their readiness to return and what's driving that. It can surface ideas for programs that will appeal to them and also identify barriers that might deter future visits.

Qualitative research is more than casually chatting with a few people as they exit your institution. While that can be informative, research conducted in a structured and purposeful way can paint a picture of the overall audience experience that transcends the stories of a handful of visitors. The following example demonstrates how one organization used qualitative research to understand how new visitors experienced its programming and identify ways to deepen engagement with them.

What Are Our New Visitors Looking For?
Interviews Help the Isabella Stewart Gardner Museum Improve on a Good Thing

Research ▶ **The Challenge:** As described in Chapter 3, the Isabella Stewart Gardner Museum tried out many new activities at *After Hours,* an after-work event geared to young adults. The staff simply didn't know what visitors thought about it all. Were they intimidated? Enticed? Overwhelmed? To better understand the visitor experience and identify ways to improve it, the museum supplemented its exit survey (described on page 72) by interviewing *After Hours* attendees. **What did young attendees think of *After Hours?* What kind of experience were they hoping to have, and to what extent did the collection and programming at *After Hours* meet those expectations?**

Research Objectives: The museum had several objectives for its qualitative research:

- Understand how groups of young adults experience the Gardner
- Identify what young adults value in the Gardner
- Explore what young adults do at *After Hours*
- Explore how young adults look at and experience works of art
- Identify what differentiates the Gardner from other art museums among young adults

Method, Research Participants, and Questions: Outside consultants from Randi Korn & Associates, research and evaluation specialists, interviewed 55 groups of visitors (a total of 184 people) at *After Hours* between November 2007 (two months post-launch) and May 2008. The researchers intercepted groups throughout the museum and near the exit, selecting them at random using an every *n*th rule.[11] Participants were taken to a separate room, where they were asked eight questions that explored their reasons for coming to *After Hours*, what they did at the event, how the *After Hours* environment impacted their experience with the collection, and ways to make the event more rewarding. After completing the interview, they filled out a short questionnaire to capture their demographics. In all, the interview took about 10 minutes.

11. See *Choose Carefully: Selecting Audience Members to Take a Survey*, on page 100 for a discussion of randomly selecting face-to-face survey respondents using an every *n*th rule.

Results: Several themes emerged after researchers examined the interviews, including:

- The museum's lighting and setting created a unique and exciting atmosphere.
- The art stimulated conversation among groups of visitors in a powerful way.
- Young volunteers and museum activities encouraged interaction with the art.
- Many young visitors were looking for a social experience that would let them interact with friends and meet new people. Some expressed disappointment that there were not enough opportunities for the latter.

Acting On the Results: When staff first conceived of *After Hours*, they worried that the Gardner's space would be too formal and off-putting for young adults. Hearing visitors say that they enjoyed the atmosphere and that the art encouraged conversation boosted the staff's confidence to move forward with the event. The interviews also confirmed that the museum's younger volunteers made visitors feel welcome and encouraged them to explore the galleries. That finding prompted staff to expand their corps of younger volunteers. In addition, the research led the staff to brainstorm ways to make *After Hours* more of a social experience. They came up with "gallery games," activities involving the collection that let visitors interact with friends and others.

Such experiential feedback is difficult to get from a survey, making the interviews a good complement to the quantitative data Gardner gained from its questionnaire. The visitor survey told staff *what* was working; the interviews told them *why*. It was a different kind of information that helped them think more clearly about how to improve the program. Says Julie Crites, director of program planning at the time of the initiative:

> *It gave so much color to what we were doing. The researchers really dug into what people in this age group are looking for, and found that people have a deeper social experience when they are looking at art than when out at other places. It also told us that the groups want to meet other people. That forced us to ask if our programming was giving them what they wanted, and if not, how we could make that happen.*

Greater detail on Gardner's research is provided in the source case study.[12]

Cost: $20,000 to $25,000. That fee covered outside consultant time to develop the interview questions, conduct the interviews, analyze the results, and write a report with analytic highlights and recommendations.

12. See Bob Harlow et al., *More Than Just a Party: How the Isabella Stewart Gardner Museum Boosted Participation by Young Adults* (New York, NY: Wallace Studies in Building Arts Audiences, 2011), 18–20. http://www.wallacefoundation.org/knowledge-center/audience-development-for-the-arts/strategies-for-expanding-audiences/Pages/Wallace-Studies-in-Building-Arts-Audiences-More-Than-Just-a-Party.aspx.

About the Author

Bob Harlow, PhD, is a social psychologist and statistician who develops research programs that help organizations more deeply understand their target audiences. He has partnered with marketing managers and senior executives at some of the world's largest companies and leading nonprofit organizations to develop brand, communications, and operations strategies. He has held senior and management positions at IBM and at market research consulting groups such as Yankelovich Partners, RONIN, and KRC, and currently leads Bob Harlow Research and Consulting, LLC, a market research consulting organization.

Bob has written hundreds of surveys and conducted hundreds of focus groups and interviews with broad audiences in 30 countries. He has more than a dozen scholarly publications in social psychology and research methods, and is the lead author of The Wallace Foundation publication series Wallace Studies in Building Arts Audiences. He has a PhD from Princeton University in social psychology and completed the postdoctoral program in quantitative analysis at New York University's Stern School of Business and Graduate School of Arts and Science.